African and Ancient Mexican Art

The Loran Collection

Cover: Detail of Kuba raffia cloth, Zaïre

African and Ancient Mexican Art

The Loran Collection

By
Erle Loran
Thomas K. Seligman
Jane P. Dwyer
Edward B. Dwyer

The Fine Arts Museums of San Francisco

Copyright 1974 by
The Fine Arts Museums of San Francisco
International Standard
Book Number 0-88401-004-x
Library of Congress
Catalogue Card Number 74-84681
Printed on 100# Northwest Velvet Book
Designed by Ron Rick
Mechanical Production by Ron Rick,
Rick Kitamata, Wendy Kitamata
Photographs by James Medley
Typeset in Palatino by San Francisco
Design & Type Studio
Printed by Phelps/Schaefer
Bound by Cardoza/James

The Fine Arts Museums of San Francisco
Exhibited at the M.H. de Young Memorial Museum
October 12, 1974 - January 12, 1975

Contents

1
Dance Headdress (*Nimba*)
Baga, Guinea
Wood; 41″ (104.14 cm.); 1958

Weighing over fifty pounds, the *nimba* mask
is worn on the shoulders of the *Simo* secret
society dancer after the rice harvest. The
four support legs of the sculpture and the
entire body of the dancer are covered by a
fiber garment. The two holes between the
breasts allow the dancer to see. One of the
most powerful objects of the Baga, the *nimba*
are used to bring human or agricultural fer-
tility and give particular protection to a
pregnant woman from possible antagonistic
ancestors.

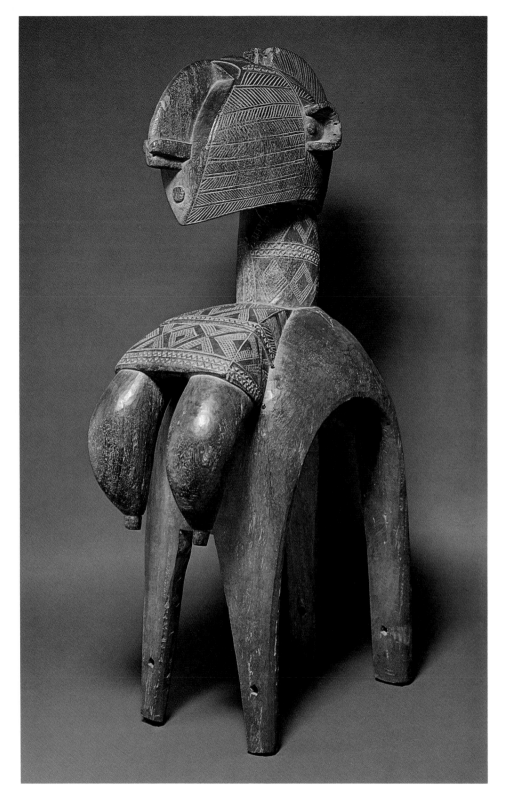

Foreword

The collection which forms the content of this catalogue and exhibition is the work of a remarkable couple who have devoted a lifetime to the arts: Erle and Clyta Loran. Erle, who has spent his entire career as painter, teacher and critic, has also shown himself to be an extraordinarily sensitive collector. After acquiring his first piece of tribal art in 1926, he continued to collect objects for the sheer enjoyment of their aesthetic qualities. Thus the collection, begun at a time when it was not fashionable to collect this kind of material as art, gives a strong insight into the aesthetic sensibilities of the Lorans. It is a collection of an intensely personal nature—one formed through love of the objects. It is indeed a privilege for the Museums to be able to exhibit these African and ancient Mexican selections.

This catalogue and exhibition are the result of the combined efforts of a number of people: the Lorans who assembled these beautiful objects and were generous enough to share them with us; Thomas K. Seligman, Curator of the Traditional Arts of Africa, Oceania and the Americas who coordinated the catalogue and exhibition through all its stages; Jane P. Dwyer and Edward B. Dwyer who have assisted us so much in the past and with whom it is always a pleasure to work; The Museum Society who at all times generously supported the exhibition and catalogue; and many others.

Ian McKibbin White

Preface

This exhibition and catalogue would not have been possible without the time and effort given by so many. To Erle and Clyta Loran, with whom I shared countless hours researching, talking and photographing, I owe my sincerest thanks. Working with such a splendid collection among friends has been a unique experience. I also want to specially thank Clyta for the excellent cuisine that she provided during this period.

Heartfelt thanks are also due to Jane and Ned Dwyer for their comprehensive research and excellent essay on ancient Mexico. I am additionally grateful to the Board of Trustees and Ian M. White for their continuing encouragement of the Department of Africa, Oceania and the Americas, and to The Museum Society for their support of both the catalogue and exhibition.

Special thanks are also due to Kathleen Berrin and my wife Charlotte, for their untiring editorial help with the manuscripts, to Helaine Fortgang for her research and encouragement, to James Medley for the fine photographs, to Roy Basich and the Museum's preparators for the spectacular installation, to Rosemary Gilbert for her secretarial assistance, and to many other members of the museum staff who helped in many different ways to realize this exhibition. Thanks also to Ron Rick for the design and production of this catalogue.

TKS

On Our Collection
By Erle Loran

The pleasure of having interesting things to look at every day explains our gathering of African and Precolumbian sculpture presented here. Making a collection was never the aim. The excitement of discovering strange new forms that would have a lasting aesthetic significance is all we ever thought about. My wife, Clyta, has joined me in making the major decisions and to my delight, she has always shown a completely unbiased instinct for enjoying the most difficult, unknown, bizarre pieces.

For this exhibition, Thomas Seligman and Jane and Edward Dwyer have written superb essays stressing religion as the dominant motivating force behind African and Precolumbian art, and it reminds me of a statement I made in connnection with a painting I exhibited in 1965 at the Krannert Art Museum of the University of Illinois:

> In the flood of styles, discoveries and movements in 20th century art, nothing has appeared that diminishes the probability that art is equivalent to religious experience, both for the artist and the beholder. Originally all art was intended for magic and religious ritual. It was used to worship gods, to perform miracles in birth and death and to embellish temples of worship. In modern times, art museums have become the cathedrals of worship for those who can no longer accept the possibility of a God or the orthodox tenets of an established faith. Artists now work for imaginary cathedrals, for gods that have no name.

I could say that the African and Precolumbian works in our home are my household gods. Obviously I cannot share a belief in the gods and ancestors who were revered by the artists who made the things we have collected. It is rather that for me art itself is religious. My faith cannot be found in any parficular god or religion; it lies in the aesthetic form created by men.

While I have not been a diligent student of the history and meaning of primitive art, I am always pleased to know what the name of a god was and the purpose for which an object was carved. Yet I have never acquired anything from this point of view. The vitality of the form, the perfection of the abstract relationships has been the basis for judgment. This attitude, so different from the approach of most anthropologists and art historians, belongs specifically to the 20th century. It explains why I have had no difficulty enjoying art from civilizations about which I know very little. The result is that we have objects from the cultures of India, China, Siam, ancient Mexico, American Indian of the Southwest and Northwest Coast, Arctic Eskimo, Africa and Spanish America. We owe it to the French modern painters who in 1904-5 first discovered that African sculpture was art.

One of the latest reminders of that event appears in <u>African Art</u> by Frank Willett (1971, p. 35-6) who says:

> One piece is still identifiable; it is a mask that had been given to Maurice Vlaminck in 1905. He records that Derain was 'speechless' and 'stunned' when he saw it, bought it from Vlaminck and in turn showed it to Picasso and Matisse, who were also greatly affected by it. Ambroise Vollard then borrowed it and had it cast in bronze by Maillol's bronzesmith. The revolution of twentieth-century art was under way.

A new appreciation of the pure abstract form and invention in all ancient and primitive art began. Reminiscing takes me back to 1926 when, living in Paris on a four-year scholarship, I recall seeing African sculpture at the French dealers. Unfortunately, it was not until much later in the forties and fifties that I began collecting it.

While I will stand by my statements about the pre-eminence of the abstract formal qualities in determining my interest and judgment, there certainly are other related factors that fascinate me. Primitive art was produced for tribal use and the artists knew exactly what they were expected to do. Long tradition and established iconography left the artist free to perfect his skill in producing known forms. And yet within limits he could express his individual inventiveness and fantasy. Within categories like the *nimba* masks (plate 1) of the Baga tribe it is very easy to recognize this strange form but no two will be identical. Otherwise they would be mere copies made for sale. A genuine piece must be infused with new life, which can only develop from the sincere, devoted feeling of the artist. The work is made to represent a god or ancestor idea but it must also be a pure creation to have the vital force and tension that makes it a work of art for non-tribal appreciation. What I am saying is that the tribal or collective artist has a great advantage over the modern Western artist. He works for a definite purpose and there is no doubt that he can achieve intensity of feeling and richness of quality that is difficult for the artist in modern society. Native African artists, influenced by modern Western art and working in non-traditional idioms have certainly produced nothing to compare with their traditional art. Traditional African art has qualities that are rare in the whole history of art. Ancient tradition, that has placed the meaning and purpose of this art far beyond the limitations of Greek ideals of beauty, has generated forms of highly abstract invention.

As an example, one of the most difficult objects in African art for Western appreciation is the nail fetish (*nkisi*) of the Kongo (plate 62). I suppose most people are repelled by the gruesome appearance of these figures. Certainly it is difficult to look at such pieces without feeling the power and danger they had for the tribal community. Such figures were kept by the medicine man who used them to protect, heal or cast a spell. The nails were driven into the wood in order to achieve some specific end, either for good or evil. Mystery surrounds these fetishes and some writers have suggested that they are derived from the concept of Christ crucified. Certainly these figures have great expressive power based on deep human feeling and no doubt exemplify profound aspects of man's artistic impulse. Fears, nightmares, unconscious drives that lead us into mysterious, unknown realms of fantasy and thought are motivations for artistic creation. Murder, torture, punishment play an enormous role in Christian art so it would be natural to find aspects of the hideous and frightening in tribal art as well. Such motivations can be transformed and sublimated through aesthetic form but sometimes the crude human impulses are not sufficiently refined. If that is so with many nail fetishes, they remain objects of great power and majesty; they can be enjoyed on many curious levels.

If even ugliness can be a source of interest and enjoyment, certainly exoticism should be fascinating to a collector. I shall never forget the first Wurkun yoke I saw at a dealer's gallery (plate 52). Nothing like this had ever come to my attention before. The head was so extraordinary in shape and the general proportions so unusual that I could not put it out of my mind. After thinking about it for a few days, we acquired it. The relation between the large, strangely shaped head, the long neck and the slender yoke creates what is best called tension. This feeling of tension is always the result of meaningful formal relationships which produce the energy and vitality of significant art. Another strange piece from the Jukun of northeastern Nigeria is the yoke called *wunkur* (plate 51). Again, nothing similar had ever come to our attention but the intensity of feeling that exuded from it was strong enough to give us the courage to acquire it and it has been a source of wonder and delight for us every day.

If one is restricted by limited resources, it is always a gamble to buy works that are not found in the literature of art. But as always before, the only measure of judgment for us that can be considered reliable is the vitality of the aesthetic form. The terror of collecting is the fear of buying a fake. An incident occurred in relation to this Jukun piece that has been very reassuring. One day a scholar who has not yet published his research on this comparatively unknown territory came to see our collection. He immediately recognized the yoke as a piece he had studied and photographed *in situ*. Only rarely is it possible to authenticate a piece of African sculpture in such a positive way.

I have talked in a random way about some of the varieties of African art that are difficult to accept from any conventional Western standard of beauty, but I also admire many types that are quite pleasant. The Bambara antelope headpiece called *chi wara* (plates 11-13) is apparently one of the most widely appreciated and I wish we had more of them. African civilizations and tribes have probably produced a greater variety and range of artistic form-types than any other. There are not only an amazing number of different *chi wara* types; within these types the variations are also great. It shows again that the African artist is able to invent fascinating individual deviations that reveal his personal creative ability.

The use of the *chi wara* in agricultural fertility dances is interesting to know about, but I must admit that my appreciation and enjoyment of these highly decorative forms is not particularly enhanced by the knowledge. It remains information which is valuable as an end in itself. When ancient or tribal art is put in a museum or a home, it takes on a purpose and meaning that was of little concern to the artist or tribe that produced it. The intended use for many works will never be known, but does it not glorify an object to admire it as art? In my view, nothing could be more reverential.

The general acceptance of African art for its decorative value has unfortunately led to mass-production intended entirely for sale in Western markets. The proliferation of the *chi wara* is an outstanding example. This problem of the fake in art haunts every collector and dealer as well. Once a serious interest in any field of art is developed, it becomes important to learn to discriminate between the genuine and false. The greatest experts in the world often acquire unwanted celebrity for their mistakes, and this baffling situation does not add much comfort to the young collector who is trying to learn. A fake can be based on or copied from a great piece and therefore has the same intriguing abstract design, shape and silhouette. The impact of the total shape is what makes the first impression but if it is false, obscure weaknesses will in time be revealed. Only long experience can develop a discriminating eye but even that, alas, cannot be relied upon at all times. We get back to the mystery and religious nature of art. If the piece is made for ceremonial use and the artist is genuinely concerned about the importance of his role, at least the ideal conditions for a genuine creation are present. Ultimate achievement still depends on the skill and emotional power of the artist.

Interior of the Loran's living room.

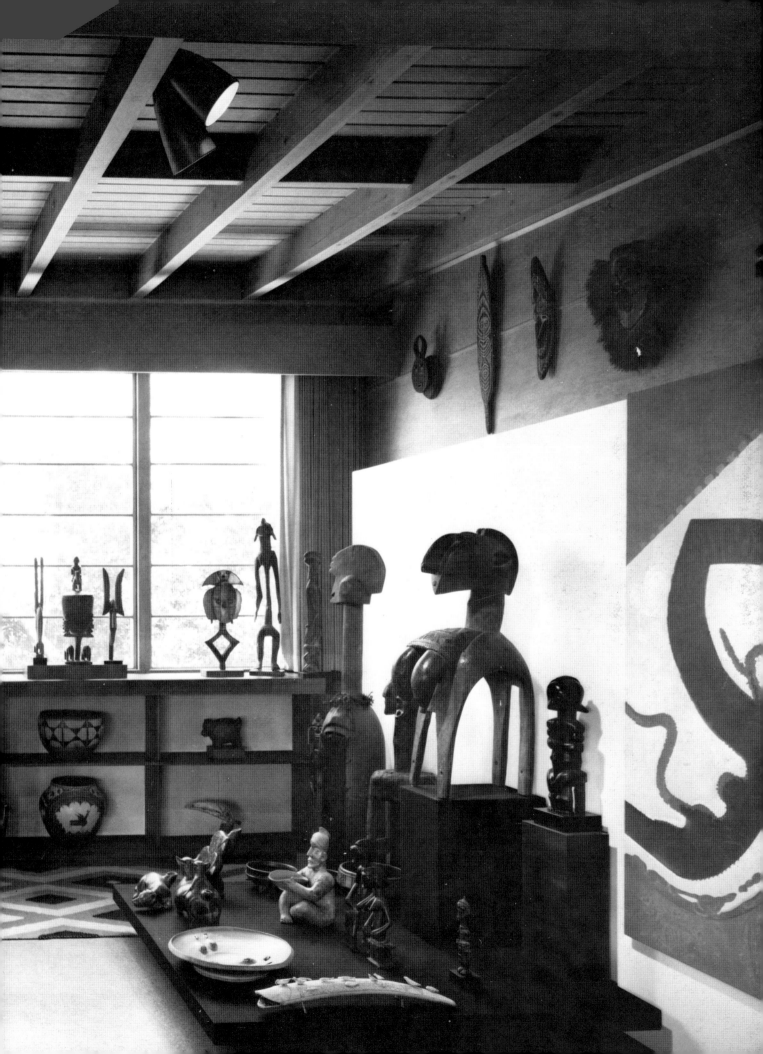

I have said nothing thus far about Precolumbian art and yet our first serious collecting began with objects from these ancient cultures. Not only is Precolumbian art fascinating and even supreme in its formal inventiveness, it was within easy reach geographically. The great pioneer dealer lived in Los Angeles. Everyone interested in the field of Precolumbian art remembers Earl Stendahl. He was a delightful and fascinating man. Museums all over the world are now magnificently embellished with incredibly marvelous works of art that would still be buried in the earth, except for the interest and love of art shared by collectors and dealers. It took courage for Earl Stendahl to invest in Precolumbian art with only the hope that he could sell it.

It is true that archaeologists and anthropologists perform a priceless service to education and the enlightenment of man with their painstaking excavation records, but how much Mexican, Turkish, Persian, Egyptian and African art would we now know about and be able to enjoy except for the collectors who liked it so much that they were willing to pay great fortunes to acquire it. In my personal view, the worst crimes of Western civilization and Islam were committed by bigoted missionaries and soldiers of God who burned and demolished the "pagan" art of other great civilizations. The natives of these ancient traditional societies were taught that their "idols" were the work of the devil and devoted to evil. In my view, all works of art are holy and they are the work of the god I worship.

While I agree that the recent treaties with Mexico and other countries forbidding the export of national treasures are right and necessary, they are simply a sign of growing enlightenment and respectful decency among nations. There is little justification for pontificating about the raids that took place in the past. Usually, the export of treasures was sanctioned and facilitated by the native rulers. Their venality is the least excusable. It makes one think also of the Spanish rulers who melted down priceless works of art for the gold they were made of.

To pursue the subject of religious bigotry, I must confess that I once had a prejudice against certain categories of Precolumbian art. I could not bear to think about the barbarity of a religion that practiced human sacrifice. On ritual occasions, black robed priests would cut out the living human hearts of victims and hold them up to the sun. Too often I thought I could see the mask or figure as revealing the horror and dread of being killed and tortured. According to many historians, notably Lesley Simpson, author of Many Mexicos, the dread of their terrifying religion is what made the common Aztec people ironically welcome the Spaniards as saviors rather than conquerors. My revulsion against such religious practices has not diminished; I would say that my perception of art forms has matured. I can now be completely spellbound by the god Xipe-Totec who wears the skin of a freshly flayed victim. The probable intention was to add the strength and vitality of the murdered victim to the power of the living representative of Xipe-Totec.

The portrayal of a hideous ritual is often so infused with the magic force of art that I can see beyond the subject depicted. Yet I will not say that the pure abstract components can be isolated in such sculptures. Perhaps my understanding of the pathos of human striving helps me to accept this barbarity as one of the endless steps in man's urge to increase his power and to achieve sublime ecstasy. The concept of Xipe-Totec is certainly one of the most outrageous devices ever invented to attain this end.

Since our own collection contains so few allusions to the religious terrorism I have been describing, it may well be that I am merely expressing regret for lost opportunities to acquire a great Xipe-Totec. But I am also pleading for tolerance and acceptance of all manifestations of art, no matter what misguided religious concept may be portrayed. The grotesque is prominent in the art of all times. In Medieval churches we had gargoyles and demons; today we have the painting of Francis Bacon. He probably outdoes all predecessors with his portrayals of rape, hatchet murders and homosexual sadism. With explicit frankness the Precolumbian peoples depicted all manifestations of disease and anatomical decay. Some malformed humans were revered as something akin to saints—the hunchbacks from Colima are one example. Our little Remojadas dog (plate 102) is depicted in the throes of death; to me he is noble and touching.

Most of our Precolumbian art is ancestral and was placed in tombs. Ceramic dogs were there to lead the souls to heaven. At the other extreme there is a dog in a Los Angeles collection that is portrayed lying feet upwards after being cooked and placed on a platter. Dogs are so precious they can lead the way to heaven but they are also valuable for maintaining life on earth as food.

I have little taste for the macabre in spite of what I have just written. I rarely think of these gruesome facts when I look at the art as noble form. The macabre has been transformed and sublimated into art; my pleasure is a fascination with aesthetic order. It requires training and experience to appreciate the art of any period. In our 20th century, abstract art has been baffling and ugly to the majority. To quote from the last page of the admirable work of Franz Boas in his Primitive Art: "I believe we may safely say that in the narrow field of art that is characteristic of each people, the enjoyment of beauty is quite the same as among ourselves: intense among a few, slight among the mass."

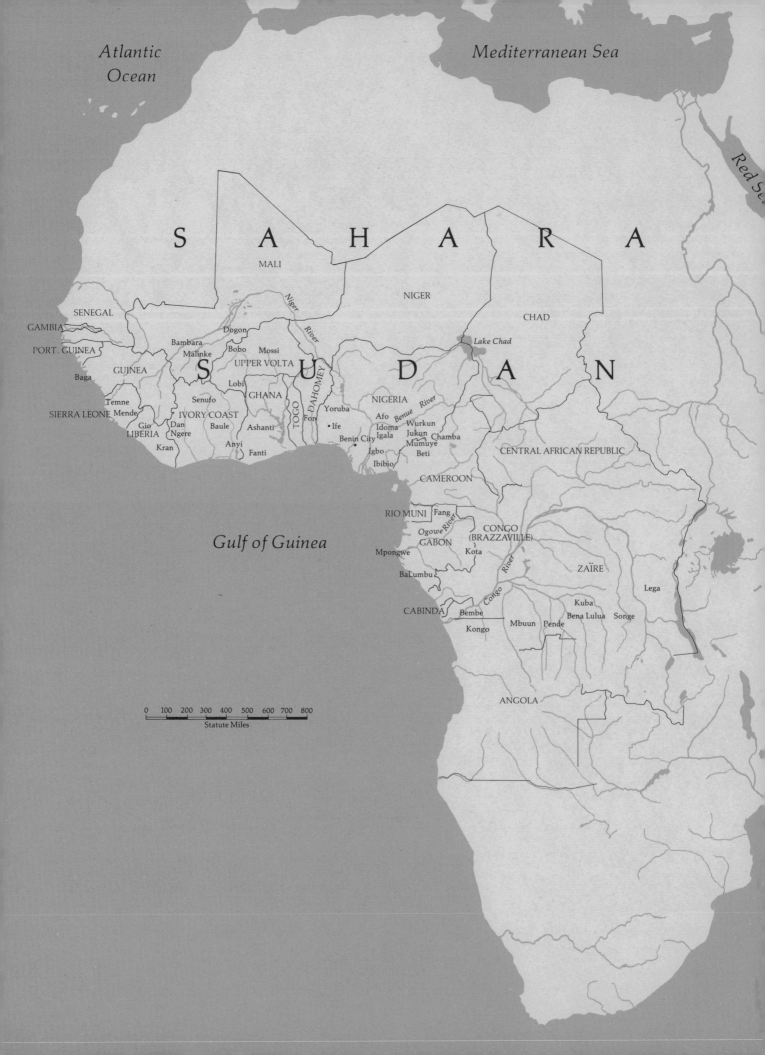

Atlantic
Ocean

Mediterranean Sea

Red Sea

S A H A R A

MALI

NIGER

CHAD

SENEGAL

GAMBIA

PORT. GUINEA

GUINEA

Baga

Temne

SIERRA LEONE Mende

Gio

LIBERIA Dan Ngere

Kran

Dogon

Bambara

Malinke

Bobo

Mossi

UPPER VOLTA

Lobi

Senufo

GHANA

IVORY COAST

Baule

Anyi

Fanti

Ashanti

S U D A N

Niger River

TOGO

DAHOMEY

Fon

Yoruba

• Ife

Benin City •

Igbo

Ibibio

NIGERIA

Afo

Idoma

Igala

Benue River

Wurkun

Jukun

Mumuye

Beti

Chamba

Lake Chad

CENTRAL AFRICAN REPUBLIC

CAMEROON

RIO MUNI Fang

Ogowe River

GABON

Mpongwe

BaLumbu

CABINDA

Bembe

Kongo

Congo River

Kota

CONGO
(BRAZZAVILLE)

ZAÏRE

Lega

Kuba

Bena Lulua Songe

Mbuun Pende

Gulf of Guinea

ANGOLA

0 100 200 300 400 500 600 700 800

Statute Miles

African Ancestors as Cosmic Connectors
By Thomas K. Seligman

African religions are energy systems that connect the people with their environments, both physical and spiritual. This primary function of traditional religions is manifest in every aspect of one's experience. As John S. Mbiti (1969, p. 3) indicates:

> In traditional religions there are no creeds to be recited; instead, the creeds are written in the heart of the individual, and each one is himself a living creed of his own religion. Where the individual is, there is his religion, for he is a religious being. It is this that makes Africans so religious: religion is in their whole system of being.

Traditional religion, termed animism by Western observers, is composed of a multitude of components and systems, all of which are ritually, cosmically and historically sanctioned. While Western religions and philosophical systems are based on opposition and dualism, African religions are based on integration and unity. In sculptural form the integral concept is illustrated by a Bambara hermaphroditic figure (plate 16) which fuses both sexes and reproductive forces into a homogeneous whole. The unifying concept is articulated by a Senufo staff (plate 34) with human heads facing in all directions, indicating the ability to completely comprehend the cosmic order.

These religious concepts are further articulated by Janheinz Jahn (1961, p. 64):

> Unlike the European, the Yoruba does not conceive the world as a conflict between good and evil, light and darkness, God and Devil. He is realistic and recognizes that all forces—even divine forces—have destructive as well as constructive possibilities. The secret of life, then, and the purpose of *orisha* [ancestor] worship is to establish a constructive relationship with these powers.

The recognition that man, nature, and the spirit world encompass all possible orders is vital to understanding the basic premise of African religions. Mbiti's explanation (1969, p. 108-109), "I am, because we are; and since we are, therefore I am" might appear confusing from a Western point of view, but it is the summation of African thought—very close in principle to Einstein's concept of relativity, and to the Dadaist idea that a shadow is one with the object.

Ancestor worship constitutes a vital part of African religions and exists in most, if not all, African societies. However prominent this concept might appear, it is by no means all-encompassing. As Mbiti (1969, p. 8) notes, "Certainly it cannot be denied that the departed occupy an important place in African religiosity, but it is wrong to interpret traditional religions simply in terms of 'worshipping the ancestors.'" Ancestors, then, are not the sum of African religion. Yet their prominence cannot be denied as they are extensively invoked through figural sculpture and masking rituals.

Ancestors are usually those spirit beings who exist between man and the supreme creator God. It is the ancestors who are the vital link—the connection that keeps the powers of spirits, universe, nature and man harmoniously balanced. According to Thompson (1974, p. 28), "Ancestorism is the belief that the closest harmony with the ancient way is the highest of experiences, the force that enables man to rise to his destiny." Ancestors keep the vital energies flowing in sympathetic rhythms, maintaining the traditional order as originally determined by the supreme deity.

The intricately ordered Dogon world view provides a case in point. The Dogon of Mali believe that the first male and female (*Nommo*) produced eight twins who became the ancestors of the tribe. A complex mythological history of the creation of the people and their customs follows from this basic union and in it, the ancestors repeatedly function as the intermediaries between man and the *Nommo*. In order to make the cosmic connection and achieve contact with the ancestors, the Dogon, as well as many other groups, carve wooden icons (plates 5 & 7) which serve as intermediaries. These icons do not represent the ancestor, they are simply vehicles for communication. The sculpted image becomes an ancestral figure only through its designation as such by the ritual leaders or elders of the tribe. As Jahn (1961, p. 109) recounts, "It is false to say that the dead 'live.' They do not 'live', but exist as spiritual forces."

As icons for spiritual contact, it is important to understand how these figures are used. Among traditional Africans, there is no universal principle for communicating with the vital energies of the spirit world. Communication can take many forms, the most common of which are prayers, sacrifices, and offerings. Although few traditional prayers appear in the literature, an interesting example of one form of ritual supplication from the contemporary Yoruba opera, "The Palm Wine Drinkard" by Kola Ogunmola, shows the rhythmic intensity, repetition and humility required if the prayers are to be successful:

> Kéye ò ! Kéye ò, Kéye ò !
>
> Kéye ò ! Kéye ò, Kéye ò !
>
> Father of the spirits !
>
> Kéye ò ! Kéye ò ! Kéye ò !
>
> Father of the spirits !
>
> Irúnmọlè ! Igbaamọlè ! Ọrunmọlè ! My respects !
>
> Kéye ò ! Father of the spirits !
>
> Spirit who is overseer of the world !
>
> Spirit who is overseer of heaven ! My respects !
>
> You are the one who supervises the world !
>
> You are the one who supervises heaven !
>
> You are the gatekeeper between the world and the expanse of heaven !
>
> My respects !
>
> Kéye ò ! Father of the spirits !
>
> Kéye ò ! Father of the spirits !
>
> Kéye ò ! Father of the spirits !
>
> Kéye ò ! Father of the spirits !
>
> Kéye ò ! Father of the spirits !
>
> Kéye ò ! Father of the spirits !
>
> Kéye ò ! Father of the spirits !

A modern contrast to this semi-traditional form is provided by Léopold Sédar Senghor, the French-educated president of Senegal who writes:

> I must hide him in my innermost view
> The Ancestor whose stormy hide is shot with lightning
> and thunder
> My animal protector, I must hide him
> That I may not break the barriers of scandal:
> He is my faithful blood that demands fidelity
> Protecting my naked pride against
> Myself and the scorn of luckier races.[1]

Although the traditional concept of prayer has changed, the basic religiosity and conceptual framework have remained intact.

Now as in the past, ancestral prayers are usually accompanied by offerings of food and valuables and/or sacrifices of animals. These respectful offertory gestures are usually undertaken by ritual leaders (diviners, medicine men, elders) for these men are closest to the spirit world. They are, in a sense, the worldly equivalent of the ancestors—the keepers and transmitters of ancestral power who have achieved their status through extensive initiations in spiritual and/or temporal contexts. The spiritual dimension of such power is exemplified by Herbert Cole's work with the Igbo (1970, p. 83):

> The spiritual side of title-taking requires the candidate to undergo a ritual death and rebirth and a period of seclusion, and to participate in blood sacrifices, ceremonial washing, the taking of new names, and the establishment of a new personal god (chi). Title-taking is therefore analogous to graded initiation, with each successive stage bringing a man closer to the ultimate concerns of his community: passage through these rites confers an element of sanctity on Ozo men—they are closer to the gods and ancestors.

And, among the Yoruba, Robert Thompson (1971, p. 228-9) explains the oba's crown (plate 48) as a temporal dimension of divine leadership:

> Yoruba gods long ago chose beaded strands as emblems. The fact that the crowns of the Yoruba leaders are embellished with bead embroidery therefore immediately suggests godhead. Indeed, the prerogative of beaded objects is restricted to those who represent the gods and with whom the gods communicate: Kings, priests, diviners and native doctors. The beaded crown therefore connotes power sustained by divine sanction.

Here we see divine kingship in its fullest articulation—the king becomes the living embodiment of the ancestor!

It is clear that the ancestors have energy and it is the desire of the living to harness that energy for their benefit. But while the ancestors can bring great harm to the people if they haven't been properly cared for, malice is not their basic intent. As Mbiti (1969, p. 83) indicates:

> The living-dead[2] are bilingual: they speak the language of men with whom they lived until 'recently'; and they speak the language of the spirits and of god, to whom they are drawing nearer ontologically. These are the 'spirits' with which African peoples are most concerned: it is through the living-dead that the spirit world becomes personal to men.

This benevolent aspect of the spirit world is further amplified by the modern Yoruba playwright Wole Soyinka in A Dance of the Forests when Agboneko, the diviner, says, "If they are the dead and we are the living, then we are their children. They shan't curse us." (1963, p. 41).

The ancestors are contacted for a multitude of needs extending from the gravest and most basic, such as ample food or consecration of ritual events, to the most mundane, like determining the most propitious time for building or taking a trip. A particularly crucial time occurs at the beginning of the growing season when the fields are about to be planted. At this time, the Bambara chi wara (plates 11-13) appear in male and female pairs, bringing with them the power of the first ancestors to insure a successful growing season. A similar practice occurs among the Baga people when the large nimba (plate 1) masquerader appears to bring agricultural and human fertility. Ancestral aid in personal fertility is of the utmost importance, as it is believed that humans and ancestors must procreate to remain immortal. This concept is further expanded by Herbert Cole (1970, p. 9) who notes:

> A man's life in Africa may be measured by the transmutations of personality assumed or undergone as he progresses from 'crisis' to 'crisis' in that ultimate recurrent cycle from birth to death, to reincarnation and rebirth.

Beyond the everyday needs of personal protection and safety, or the larger societal needs of agricultural or human fertility, there are occasional issues of drastic importance such as those occurring today in the drought-stricken Sahel. At such times, ancestors are urgently contacted to avert or lessen the effect of the calamity. The Dogon, for example, carve figures with raised arms (plate 5) that will help bring rain and thus insure fertility for continuation.

Ancestral figures can also serve to legitimize and maintain the political and social order. This usage is clearly expressed among the Kuba nation in an article by Jan Vasina entitled "Kuba Ndop" (Fraser & Cole, 1972, p. 45):

> When the king died, his ndop was put close to the death bed to catch the life force of the deceased monarch. After the successor to the king was selected he spent a certain period in isolation during which time he would be beside and sleep next to the ndop of his predecessor, thus allowing the life force of kingship to be incubated in him.

1. Totem. Gerald Moore and Ulli Beier, Modern Poetry From Africa 1963, p. 50.

2. The living-dead are those ancestors who have recently died and whose names are still remembered.

17

The ancestors as harmonizers are also capable of giving power to spirits who can, in turn, cleanse the village or tribe from illness, personal misfortune, witchcraft, social tension and a myriad of other problems. The Baule *gba gba* and *kplekple* masks (plate 41) are excellent illustrations of this process, as are the Ekpo society masks (plate 55) and figures (plate 56) of the Ibibio people. The ancestors may also function to ward off evil powers, especially those from witchcraft. This practice can be clearly seen among the Kota and Fang people of Gabon whose ancestral reliquaries (plates 60 & 61) are used to drive off malevolent supernatural forces.

During a lifetime, the ancestors invest every act, every word, and every thought with their energy. At birth, a child will often be named after a venerated ancestor so that he will acquire extra strength. During initiation rituals the ancestors are present in many forms, helping to prepare the initiate for complete integration within the group. At such times, masks which represent various aspects of ancestral power and wisdom appear in order to instruct initiates. Literally hundreds of masks are used to convey tribal traditions to initiates among the complex secret initiation societies such as the *Poro* and *Sande* of Liberia and adjacent areas of Sierra Leone, Guinea, and Ivory Coast (plates 38 & 39). Masks from these areas also function to maintain the traditional social system that was established long ago by the ancestors.

Vitally important in life, ancestral intervention becomes especially crucial at death for that is when the deceased moves towards the realm of the ancestors. As Mbiti (1969, p. 149) says, "Death stands between the world of human beings and the world of the spirits, between the visible and the 'invisible.'" After a person dies, his vital force is released in the cosmos, and proper rituals must be conducted to insure that it is brought into the realm of the ancestors where it can be contacted and used for the benefit of the living. The dimensions and concepts of time become important at this juncture, for a recently deceased tribal member is still known and remembered by his relatives and tribe and thus, is nearer in time and space to them. After a few generations the ancestor, if he has been helpful and was important enough to continue to be remembered, moves to the realm of the deified ancestors—the spirits and gods. At this point, the ancestor's prominence is firmly established and he has become a part of the tribal tradition.

In traditional sculpture, the ancestors communicate through icons, emblems, and masks. However, the ancestors are so close and their energy is so vitally important, that their presence extends into virtually every act. The prodigious number of ancestral sculptures does not represent the only means of spiritual contact. As Thompson (1974, p. XIV) indicates:

> Received traditions of standing and sitting and other modes of phrasing the body transform the person into art, make his body a metaphor of ethics and aliveness, and, ultimately, relate him to the gods.

And, while the ancestors and their energy are not visible to us, as Mbiti (1969, p. 79) points out, they are highly visible in every way to the traditional African:

> Spirits are invisible but may make themselves visible to human beings . . . They are 'seen' in the corporate belief in their existence.

The ancestors, then, are connectors between man and the universe. They keep the energy flowing harmoniously and rhythmically—maintaining everything in its proper balance, thereby insuring that the rhythm of human history will continue forever.

The only dimension given is height in inches and centimeters. The date after the dimensions indicates the year the Lorans acquired the object.

2
Equestrian Figure
Dogon, Mali
Wood; 27" (68.58 cm.); 1971

To the Dogon, dwellers of the inhospitable cliffs of the Bandiagara escarpment, sculpture reflects the mythical traditions of the people. The Dogon believe the creator god *Amma* and eight *Nommo* created the world and its systems. The seventh *Nommo*, the blacksmith, descended from heaven on a horse carrying a piece of the sun (live coals) and the ancestors of human beings. This equestrian figure relates to the descent of the seventh *Nommo* and is carved in the old Tellem style. The Dogon say they obtained this carving style from the cave-dwelling Tellem who were displaced by the Dogon in the 14th century.

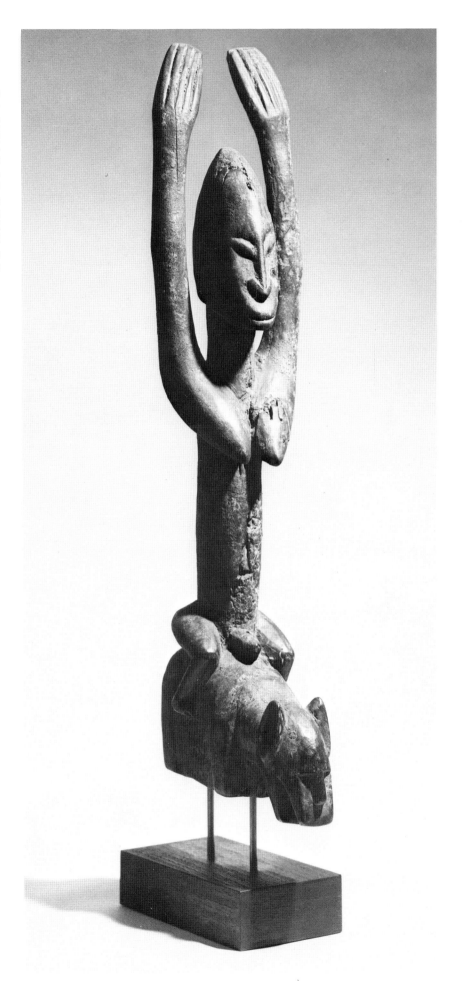

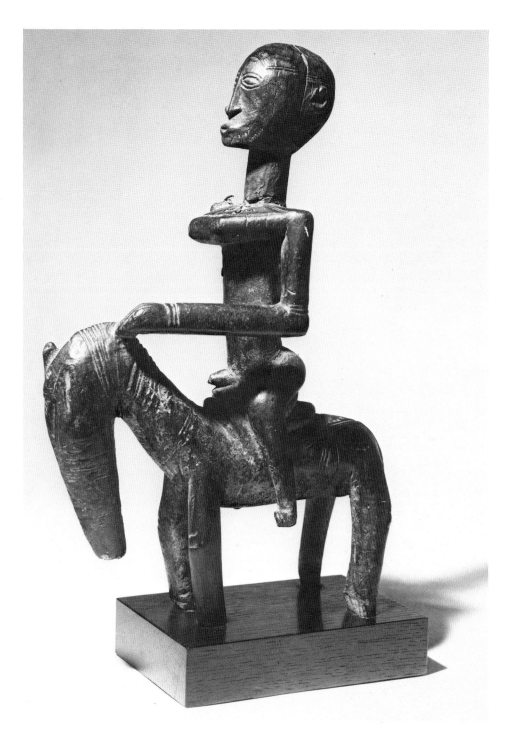

3
Equestrian Figure
Dogon, Mali
Wood; 13¼″ (33.65 cm.); 1961

This horseman is carved in a style which, according to Fagg, developed at the end of the 19th century. The rider, possibly a hermaphrodite, is believed to have the vital powers of fertility under complete control. The figure is a unifier—a maker of order out of disorder. The figure's missing right arm probably once held a lance aloft as is common among Dogon equestrian figures. It is interesting to note how the angular, rigid lines of the dominant rider (man) are harmoniously blended with the more fluid lines of his mount (nature), reinforcing the dualistic idea of bisexuality (male = rider, female = nature).

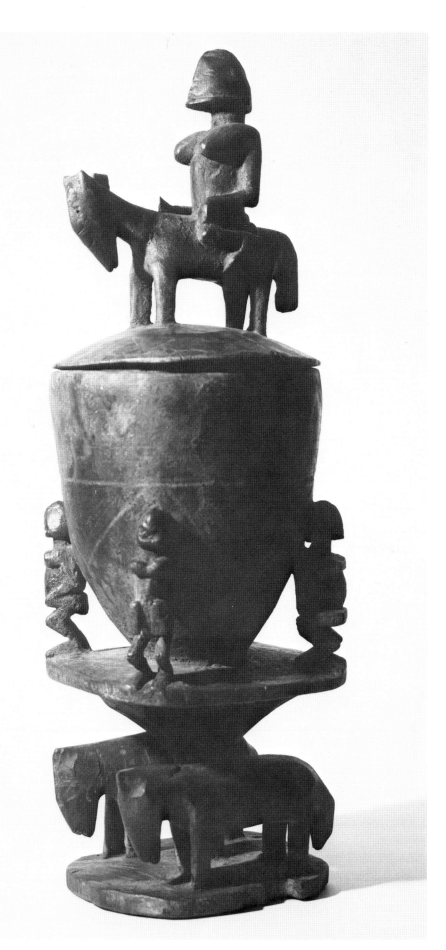

4
Lidded Vessel
Dogon, Mali
Wood; 25½″ (64.77 cm.); 1970

Lidded vessels, supported either by horses or donkeys and surmounted by an equestrian figure representing the seventh ancestor (*Nommo*), the blacksmith (*Hogon*), were used to contain a mixture of mutton and donkey meat at the festival celebrating the harvest. The Dogon believe the donkey to be the animal closest to man because of its independent nature. The *Hogon* on the lid has bent arms and legs, a reference to the Dogon legend concerning the seventh *Nommo's* descent from heaven. According to the legend, this ancestor landed so heavily onto the earth that he broke both arms and legs, thereby forming the elbow and knee joints, thus freeing man to work.

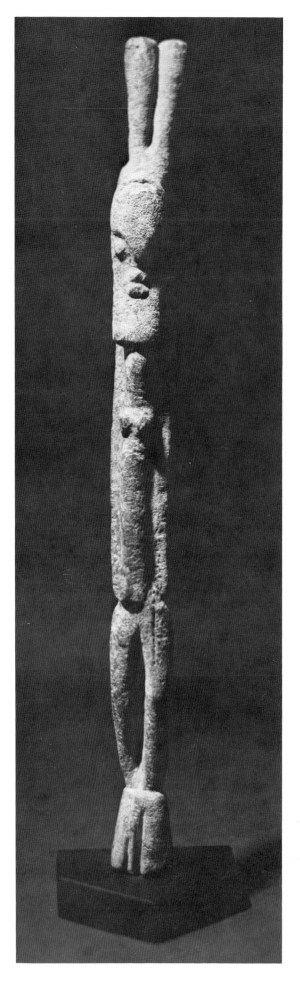

5
Figure With Raised Arms (*Nommo*)
Dogon, Mali
Wood; 21¼" (53.97 cm.); 1968

After the supreme god *Amma* created the
earth from a lump of clay, he sent the pri-
mordial couple and eight *Nommo*, each of
whom was bisexual, to people the earth.
Following the primordial couple, the eight
Nommo began the eight human lineages.
The *Nommo* with raised arms displays a
number of mythical elements: reaching to
heaven for rain, invoking fertility, and rein-
forcing the continuity of the cosmos. These
figures, carved in the style of the ancient
Tellem, are found in cliff caves where they
were placed after being given sacrifices and
coated with blood and millet gruel.

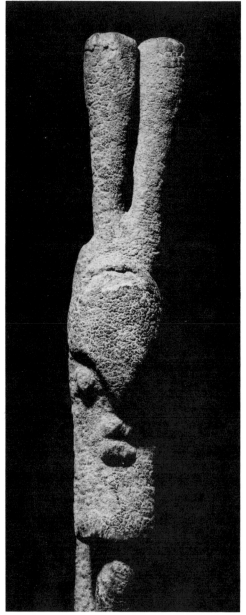

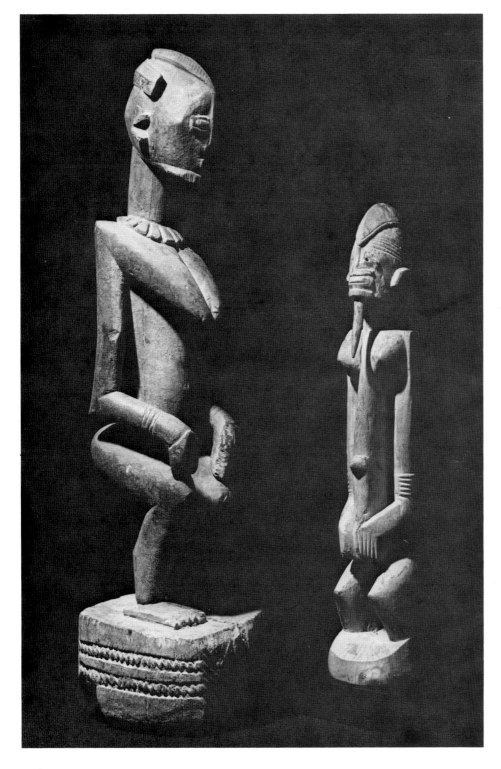

6
Female Figures
Dogon, Mali
Wood; 29¾" (75.56 cm.), 22" (55.88 cm.);
1965, 1953

The figure on the right, depicted in a clearly documented style, was probably carved by a sculptor known as the Master of Ogol (Laude, 1973). Called *dege dal nda* (statues on the terrace), these figures were kept in the house of the *Hogon* until clothed and placed on the deceased's terrace during his funeral. This particular figure may depict the master *Hogon*, represented with female aspects dominant. The projection under the chin is probably a lip plug and is characteristic of this style.

The figure on the left is a more generalized version of an ancestor and one in which female characteristics again dominate. The calm expression contrasts sharply with the tension of the legs and arms, although this conflict is beautifully unified in the sculpture.

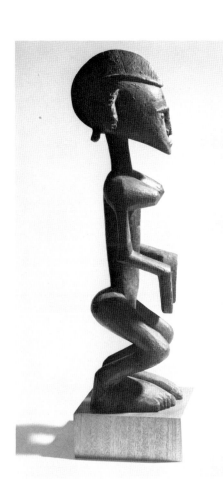

7
Female Ancestor Figure
Dogon, Mali
Wood; 20″ (50.8 cm.); 1970

Probably representing a female ancestor, this figure illustrates the frequent difficulty in attributing objects from the Western Sudan. The piece is not unequivocally Dogon, for it combines traditional figural elements of the Bambara (hands) and the Malinke (facial expression) with a Peuhl headdress. Whatever its specific origin, the figure is certainly a masterpiece of structural dynamism, scarcely containing its energy within the outlines of the form.

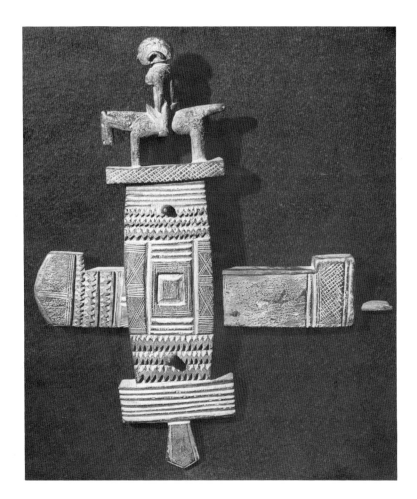

8
Granary Door Lock
Dogon, Mali
Wood & Iron; 19¼″ (48.89 cm.); 1968

Grain is the only staple among the Dogon and according to their mythology, the first millet seed was identified with the *Hogon* (blacksmith). Grain is stored in circular and square granaries, each closed by a carved wooden door which recounts one of the creation myths. These doors are secured with wooden locks bearing a specific symbol which identifies the owner. In this case, the owner probably was a *Hogon* as his symbol is the equestrian figure.

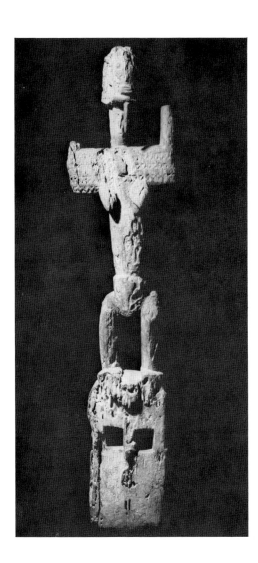

9
Mask (*Satimbe*)
Dogon, Mali
Wood; 34¾" (88.26 cm.); 1970

The Dogon masking society, called *Awa* (cosmos), utilizes many different mask types in various ritual performances. While figures are carved by the *Hogon*, masks are often made by those who will wear them. After they have been used, they are generally discarded in the cliffs where they eventually erode. This mask was probably once a *satimbe* mask, an antelope head surmounted by a standing female figure.

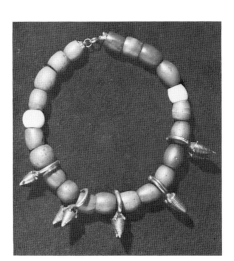

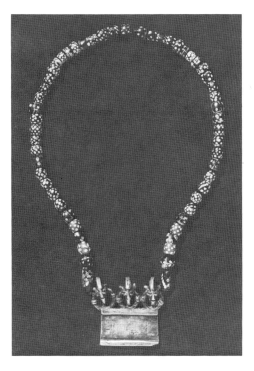

10
Necklaces
Bobo (?) & Dogon (?), Upper Volta & Mali
Beads & Brass; 13½" (34.29 cm.), 9"
(22.86 cm.); 1968, 1972

Enhancing the beauty and prestige of the wearer, jewelry has always been an important aspect of African visual arts. These two necklaces show the creative resourcefulness of their makers, for they combine European and locally made beads with brass ornaments. They also illustrate an interesting phenomenon of cross-cultural trade. Originally made in Europe, such trade beads found great demand in Africa. Today, the same beads are supplied by Africa to meet the increasing demand for them from America.

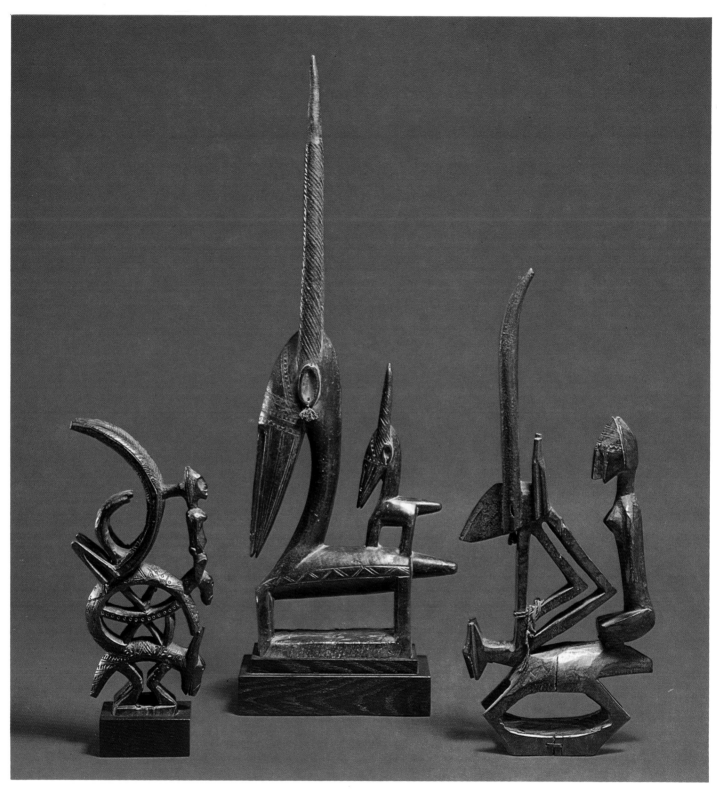

11
Antelope Headdresses (*Chi wara*)
Bambara, Mali
Wood; 19½″ (49.53 cm.), 25¾″
(65.40 cm.), 11¾″ (29.84 cm.);
1970, 1955, 1952

One of the best known sculptural forms from Africa is the famous *chi wara* of the Bambara. Recently called Bamana, the Bambara are one of the largest and most important tribes of the Western Sudan and are descendants of the powerful empires of Segu and Kaarta. The Bambara believe that the universe was created and ordered by *Faro* who is often symbolically depicted as an antelope (*chi wara*). In the legendary past, this antelope taught men how to cultivate the land. These headdresses, attached to the dancer's head by a basket cap, always appear in male/female pairs at the beginning of the planting season and at the conclusion of the puberty celebrations. The combination of the sexes and the timing of their appearance indicate these masks are used to invoke fertility in both man and nature. These three females all carry their young on their backs. The *chi wara* on the left possibly shows the female antelope riding on the back of an aardvark.

12
Antelope Headdress (*Chi wara*)
Bambara, Mali
Wood & Shell; 23″ (58.42 cm.); 1952

This male *chi wara* from the Segu area is a classic example of the sculptural form representing the powerful ancestor who taught the Bambara how to cultivate the land. The strong upthrusting horns relate the power of the antelope to the heavens, thus uniting earth and heaven. The small cowrie shell hanging from the ear is a symbol of wealth and prestige as well as a delicate accent of color.

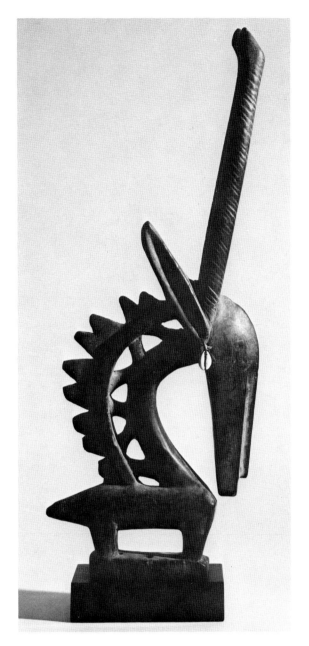

13
Antelope Headdress (*Chi wara*)
Bambara, Mali
Wood & Metal; 16¼″ (41.27 cm.); 1965

This unusual type of *chi wara* from the Bamako area is a male depicted in horizontal form. It is particularly interesting because it is constructed from several separate elements and not carved from a single block of wood. This *chi wara* is difficult to interpret. The three horns issuing from the neck may be a stylized mane or may depict additional horns which give greater strength and power to the headdress. Whatever the interpretation, the headdress is a beautifully conceived sculpture.

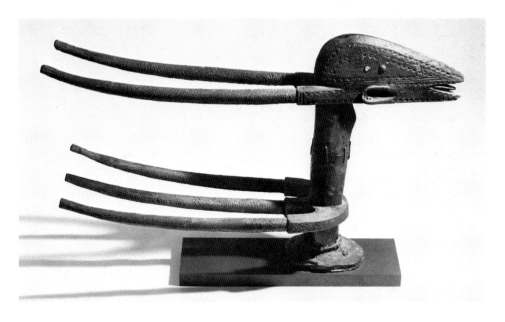

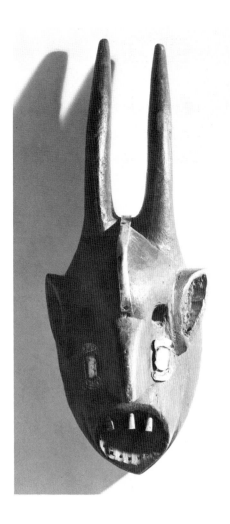

14
Antelope Mask
Bambara, Mali
Wood, Metal & Mirror; 18¾″ (47.62 cm.);
1973

This *Koré* society mask combines the power
and attributes of the mythical antelope (*chi
wara*) within the traditional mask forms of
the *Koré*. The society is divided into eight
sections, each represented by a different
type of animal mask such as hyena, mon-
key, antelope, lion, or horse. All these
masks perform in ceremonial plays designed
to bring rain and increase, and ease societal
tensions. The masked dancers, who often
bend their knees in respect to *Faro*, the
great creator, perform in a secret area open
only to *Koré* initiates. These masks and the
members of the society honor *Faro's* attri-
butes as the god of nature.

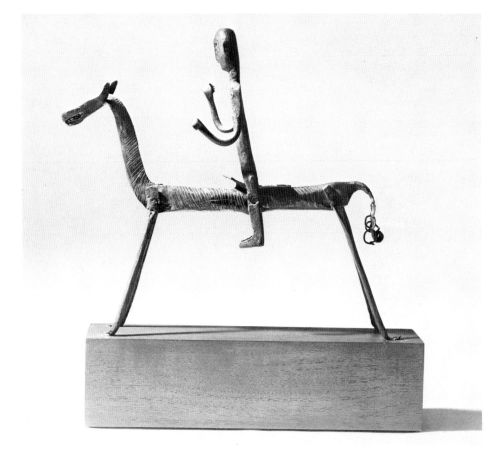

15
Equestrian Figure
Bambara, Mali
Iron; 7½″ (19.05 cm.); 1969

According to Goldwater (1960), the Bam-
bara produce iron staffs which are often
surmounted by equestrian figures. These
staffs were the personal property and family
insignia of tribal chiefs. Though there is no
evidence that this example was ever con-
nected to a staff, it is typical of the kinds of
figures which surmount Bambara staffs. It is
an interesting depiction of the familiar
mounted man as well as a remarkable study
in technology. The piece was made from
individually forged segments which were
then joined using iron peg-connectors.

16
Hermaphrodite Figure
Bambara, Mali
Wood; 13½" (34.29 cm.); 1951

The hermaphroditic characteristics of this figure form a direct link between the ancestor's dual role as promoter of fertility and connector of the cosmos. Opposing concepts such as male/female and heaven/earth are beautifully integrated within the piece, reflecting a complete and harmonious balance within the universe. The philosophical dualism is visually reinforced by the juxtaposition of round and angular planes, smooth and incised surfaces, open and solid volumes, and calm and tense demeanor. Probably ancestral, this figure may have been used to promote fertility and increase.

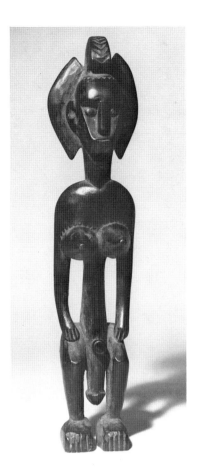

17
Housepost
Bambara, Mali
Wood; 75½" (191.77 cm.); 1973

This large housepost, carved of a very hard and heavy wood, depicts another hermaphroditic figure which was probably a symbol of ancestral fertility and increase. The post may have supported the corner of the roof of one of the men's society houses and recalls the better known houseposts of the Dogon which support the *toguna* (men's shelter). This piece is of particular interest because it has been formed into a vibrant geometric pattern, climaxing in a beautiful upsweeping curve symbolizing the unity of heaven and earth.

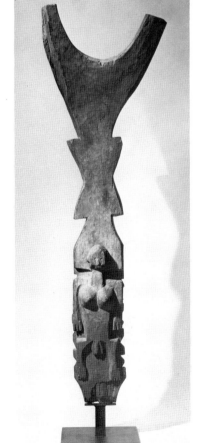

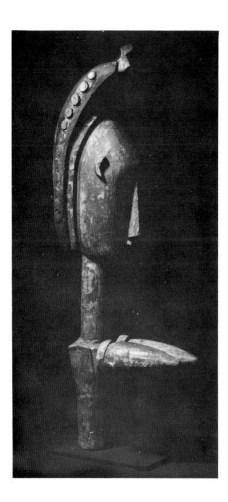

18
Marionette (*Merekun*)
Bambara, Mali
Wood; 30¼" (76.83 cm.); 1970

Marionettes appear in *Koré* society cere-monial plays which ridicule the most sacred tribal objects and customs, especially sexual practices. The marionettes are used by the *Koré duga* (leader) as puppets which portray the subjects of ridicule. This female marion-ette probably once had arms and a long dress which hid the puppeteer from view. Reports indicate the marionettes are still in use today, although their ritual purpose has been lost and they only perform in secular plays for popular entertainment. They are carried by dancers hiding under the long dress and move to accompanying drums.

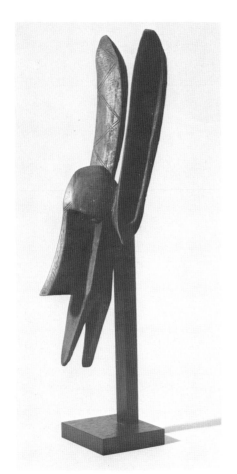

19
Hyena Marionette Top
Bambara, Mali
Wood; 18" (45.72 cm.); 1955

Probably the top of a hyena marionette, this head very closely resembles the hyena masks of the *Koré* society in diminished scale. It is also possible that the head was once attached to a long stick, thereby forming a mythical horse upon which the *Koré duga* (leader) rode while assaulting the sky to bring rain. In either case, the sculptural form clearly shows how the Bambara combine animal and human features into a visual unity.

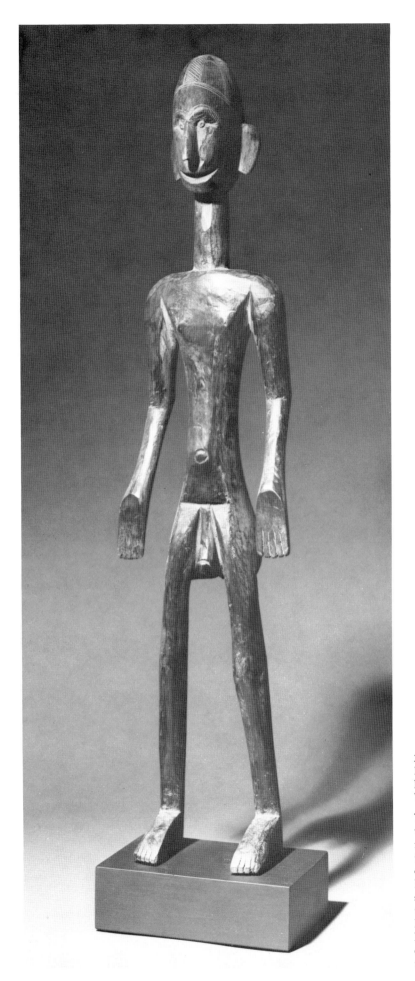

20
Male Ancestor Figure
Malinke, Mali
Wood; 25½″ (64.77 cm.); 1952

The Malinke, a small Mande speaking group
west of the Bambara, have produced a few
male and female carvings which are thought
to be ancestral figures and/or fertility
charms. Their close stylistic similarity to
Bambara figures from the Bamako region
suggests that they might have a similar func-
tion, an idea which is further confirmed by
Kjersmeier's field work (1935-38). The
Malinke figures are usually more fluidly
conceived and given less ornamentation
than their Bambara counterparts.

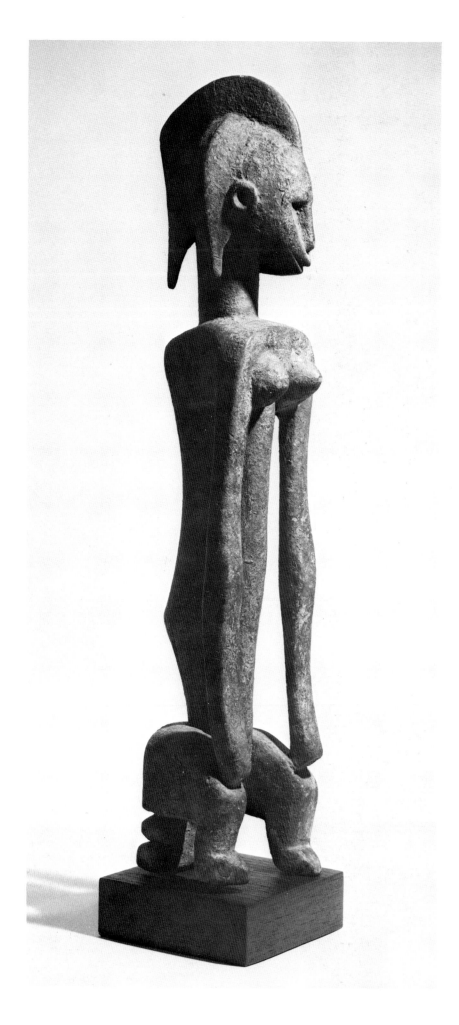

21
Female Ancestor Figure
Malinke, Mali
Wood; 28" (71.12 cm.); 1971

The quiet repose expressed in this figure
beautifully conveys the serenity and peace
achieved only by ancestors. This composed
female, in the full bloom of pubescence, is
typical of the youthful vitality found in the
Malinke and Bambara ancestral figures.
Often such figures are called queens because
their postures are regal and dignified. This
figure's full breasts tend to confirm Kjers-
meier's report that carvings of this type were
danced by young girls in hopes of promoting
fertility.

22
Mask With Standard
Bobo, Upper Volta
Wood; 70" (177.8 cm.); 1971

Although little field work has been conducted among the Bobo, their main ritual society (*Do*) produces various types of masks for member funerals and for the more general function of village purification. This large mask recalls similar types used by the neighboring Dogon and Mossi tribes. The long and pensive face is surmounted by an openwork standard of triangles. Possibly this configuration represents wings which symbolically ease the burden of the carrier and at the same time provide a closer link to the heavens. There is only slight indication that this mask was painted as is usually the case with similar Bobo masks.

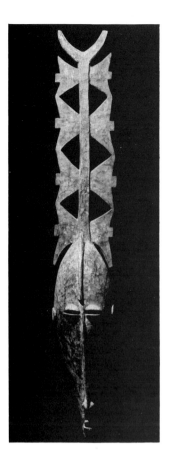

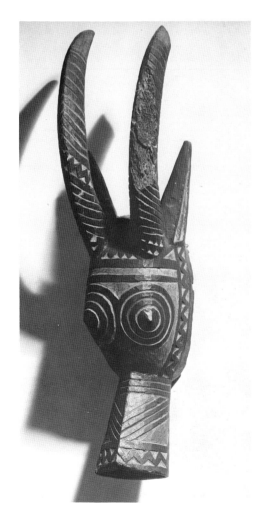

23
Antelope Mask
Bobo, Upper Volta
Wood & Paint; 22¼" (56.51 cm.); 1952

This is a very unusual example of one Bobo mask type for unlike most other known examples, it appears only to have been partially painted. It does, however, show considerable wear inside, indicating that it must have appeared in several *Do* masquerades, and one must conclude that it was stripped of most of its ceremonial paint before being sold outside the tribe. Here again the antelope is represented, symbol of agricultural fertility. This mask was probably danced in the fields at the beginning of the agricultural cycle.

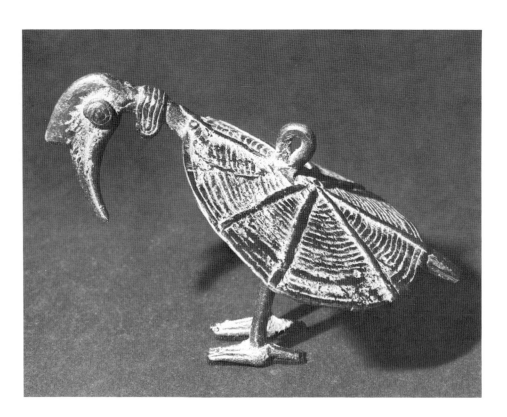

24
Bird Pendant
Bobo, Upper Volta
Brass; 4¼" (11.43 cm.); 1973

According to Leuzinger (1972), brass pendants and rings used by the Bobo are generally imported from their southern Senufo neighbors. However, the stylistic integrity of brass examples such as the one shown here, as well as evidence that the Bobo have a great number of their own smiths, indicate that such pieces were probably made locally. This conclusion is further supported by recent field work conducted among the Bobo (Bravmann). This bird closely resembles the form of a number of Bobo wooden masks, indicating its possible association with the *Do* society.

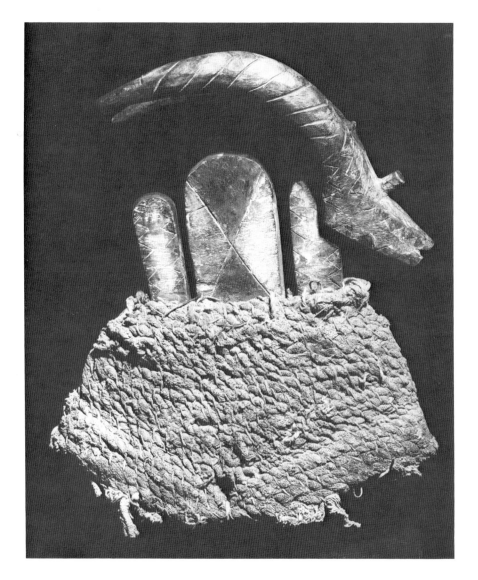

25
Antelope Headdress
Mossi, Upper Volta
Wood, Paint & Fiber; 11½" (29.21 cm.); 1973

For centuries, Mossi kings have been Moslem, but their religious influence never extended far enough outside the capital of Ouagadougou to prohibit most Mossi tribal members from practicing their ancient animistic beliefs. The Mossi still believe the antelope to be the mythical ancestor who taught them the skills of cultivating the land and harvesting the crops. This polychrome antelope recalls the Bambara *chi wara* as well as similar antelopes of the Kurumba. Some reports indicate the possibility that the Kurumba smiths are the carvers of many Mossi masks.

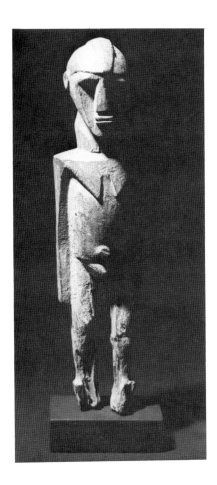

26
Female Figure
Lobi, Upper Volta
Wood; 17" (43.18 cm.); 1972

The Lobi, who inhabit the very southern part of Upper Volta and the northwestern part of Ghana, have only a few documented examples of their art. Bravmann (1970, 1973) indicates that personal protection is the major purpose of Lobi figural sculpture. Figures such as this example are kept either in a special shrine room within the family compound or in the family sleeping room. They are sometimes given lavish sacrifices to ensure their effectiveness. The termite damage to the legs of this figure probably resulted from its placement on a mud altar. The distinctive, rounded, helmet-like head possibly refers to an old custom of wearing a calabash as a hat, or possibly represents a hairstyle with a central ridge.

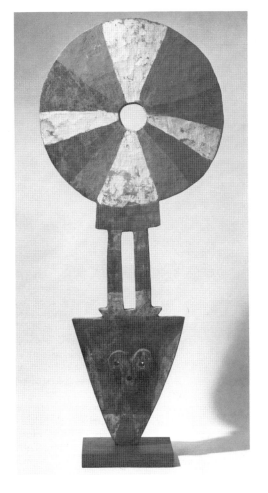

27
Headdress (*Bedu*)
Kulango or Nafana, Ivory Coast
Wood & Paint; 58¾" (149.22 cm.); 1966

Mask headdresses of this type belong to a small cluster of villages in the Cercle de Bondoukou in the eastern Ivory Coast. Such headdresses perform in pairs at the *Zaurau* festival marking the end of the harvest season, or at the death of an important elder. During the *Zaurau* month, the masqueraders dance through the village in full raffia costume. They are believed to aid women in conception, cure illness, and generally avert misfortune by easing social tension and disruption. Although the *bedu* tradition is no more than two generations old (Bravmann, 1974), its positive focus has attracted many adherents, causing it to be a very popular and important tradition. This particular headdress is female, since males have horns instead of the disc standard.

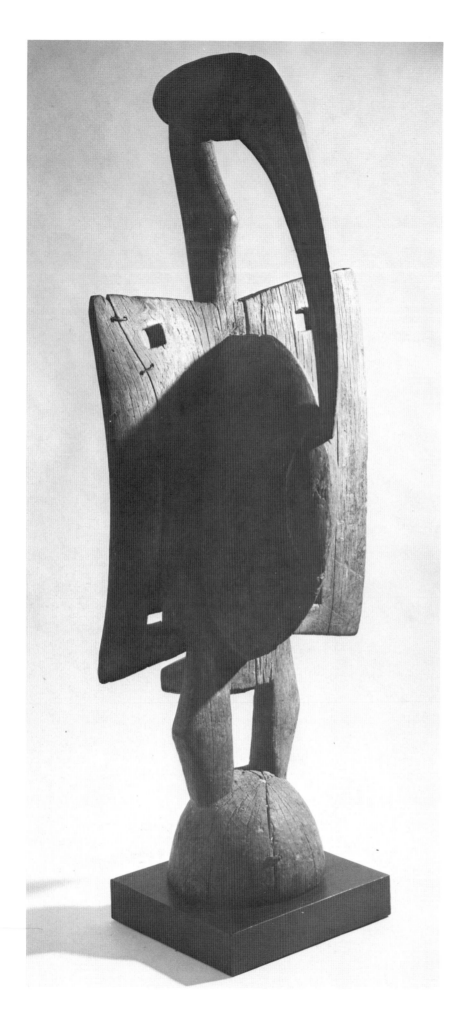

28
Hornbill Bird (*Porpianong*)
Senufo, Ivory Coast
Wood; 53¼" (135.25 cm.); 1965

The Senufo are one of the largest sculpture producing groups in West Africa. They live in the central and northern parts of the Ivory Coast centered around Korhogo. According to Senufo myths, the hornbill was one of the first five living creatures created by god and the first to be killed for human consumption. In addition to its special ancestral and totemic significance, the form of the bird symbolizes increase. The large stomach reflects a plentiful food supply as well as reproductive fertility—the two most basic types of increase. These large sculptures function as valuable cult objects of the *Lô* society where they symbolize the forces of living increase in the universe.

29
Fetish Figure (*Kafiguélédio*)
Senufo, Ivory Coast
Wood, Cloth & Feathers; 40″ (101.6 cm.);
1972

Although information regarding these fe-
tishes is scant, they were probably used to
invoke evil spells directed against victims.
Such fetishes generally come from the cen-
tral Senufo area around Korhogo and were
not documented prior to 1950. This is a
particularly exciting example because the
wooden figure under the encrusted cloth
appears to be very finely modelled. In fact,
the underlying carving may have originally
served as an ancestral figure, whose function
was later changed to one of malevolence.

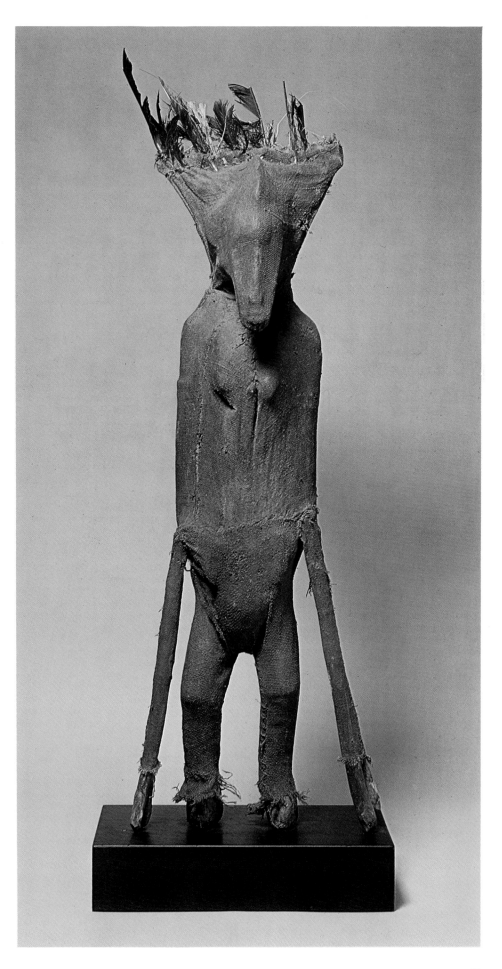

30
Two Helmet Masks (*Déguélé*)
Senufo, Ivory Coast
Wood; 27" (68.58 cm.), 28¼" (71.75 cm.);
1968

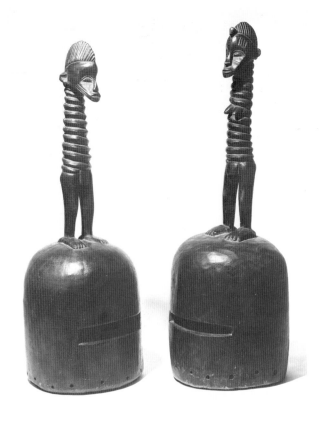

Found only among the Kiembara faction in
the Korhogo region of the Ivory Coast, hel-
met masks such as these always appear as a
male and female couple (Goldwater, 1964)
and are restricted to the highest members of
the *Lô* society. They appear at night, unseen
by non-initiates, and at the burial of impor-
tant *Lô* society members. The strength and
force of these masks is symbolized by the
number of carved rings on the figure, and its
energy is consecrated by the highest ances-
tors of the *Lô*. The male figures often have
an empty quiver on their back, thought to
contain lightning arrows.

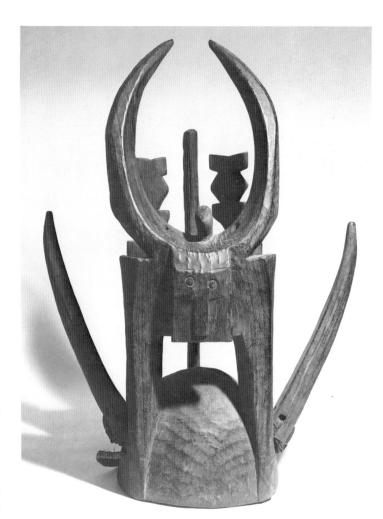

31
Helmet Mask
Senufo, Ivory Coast
Wood; 25" (63.5 cm.); 1972

Senufo helmet masks are often abstract com-
posites of various bush animals such as buf-
falos and antelopes. This example, probably
from the northern Senufo area around Si-
kasso, contains two buffalo representations.
One buffalo appears on the standard, sur-
mounting the other on the domed helmet.
Although the exact function of this mask is
unknown, it was clearly meant to impress
viewers with its power.

32
Headdress (*Kwonro*)
Senufo, Ivory Coast
Wood; 20½" (52.07 cm.); 1972

This flat, geometrically abstract board was once attached to a wicker cap and worn by initiates into the middle or adolescent grade of the *Lô* society. Upon close inspection, the strong geometric pattern reveals a reptile, very similar in form to Dogon images and probably a totemic ancestor of the particular *Lô* grade. The headdresses were worn by dancers with white cowrie shell belts which crossed their naked chests, further enhancing the abstract black and white pattern achieved by the headdress.

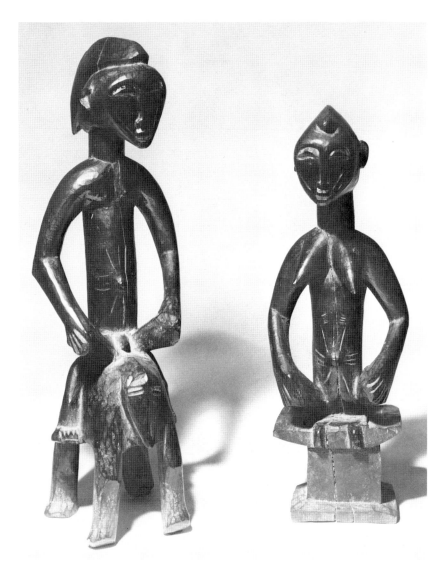

33
Equestrian and Seated Figures
Senufo, Ivory Coast
Wood; 16½" (41.91 cm.), 14" (35.56 cm.); 1962

Primarily concerned with fertility, Senufo ancestors are often depicted in pairs. This pair, probably from the northern Sikasso area, clearly shows the great power and respect given to human ancestors since these figures dominate both horse and stool. The figures are sculpturally integrated with their supporting structures and simultaneously dominate them. Senufo ancestral sculptures often have multiple purposes: ancestor figures, fertility figures, and divination figures used by the female *Sandogo* divination society.

34
Staffs
Senufo, Ivory Coast
Wood & Iron; 61" (154.94 cm.), 30½"
(77.47 cm.); 1972

The precise function of these staffs is diffi-
cult to determine. It seems probable that
they are related to the *daleu* staffs awarded
to the champion cultivator (*sambali*), since
the familiar published examples of the *daleu*
are surmounted by a female figure. The head
and stylized figure seen on the example on
the left might be a regional stylistic variation
of the female figure. The other staff, rhyth-
mically sculpted with opposing faces and
rings, ends in a flat, bronze blade that is
reminiscent of the blade of a short handled
hoe used by the men when cultivating the
fields. The faces, looking in all directions,
possibly symbolize a senior initiate's mas-
tery of the highest *Lô* grade. This grade
includes a secret language which insures the
initiate a position of respect and authority in
the society.

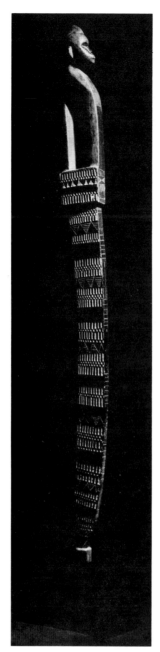
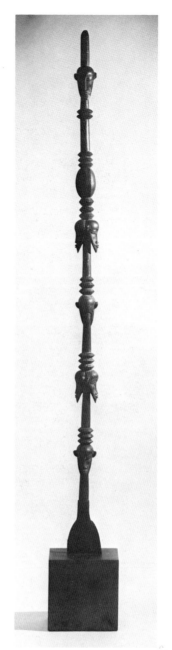

35
Headrest
Senufo or Baule, Ivory Coast
Wood & Fiber; 7½" (19.05 cm.); 1973

Although the horse is not indigenous to
Africa, it has become an integral part of
African life, being used for the transport of
wealthy and high-ranking leaders in African
societies. In the Western Sudan, horses have
been closely associated with conquering
armies, dominance, and prestige. This
horse, stylistically combining certain Baule
and Senufo features, was probably used by a
wealthy person as a headrest to protect an
elaborate coiffure.

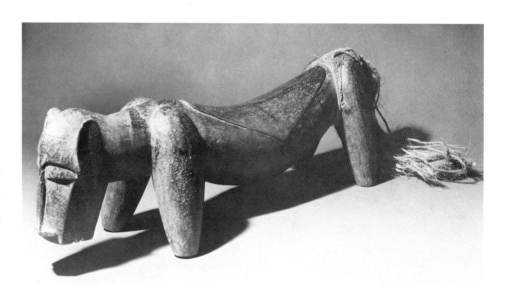

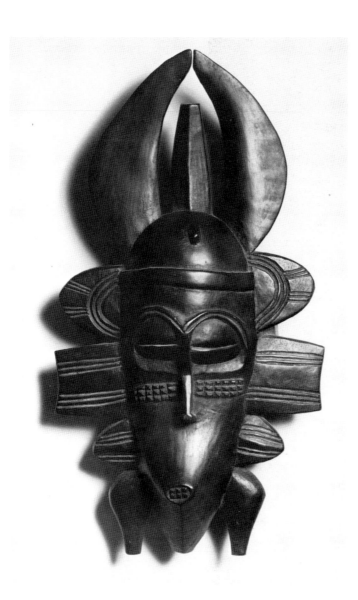

36
Face Mask (*Kpélié*)
Senufo, Ivory Coast
Wood & Paint; 13¾″ (34.92 cm.); 1951

These small face masks, worn by men of
the *Lô* society, are said to represent the
ancestors at various *Lô* rites: initiation cere-
monies, funerary ceremonies and harvest
festivals. The masks represent the face of the
dead ancestor and are surrounded with dis-
parate iconographic elements such as ante-
lope horns symbolizing the power of nature,
incised geometric shapes on the sides of the
face possibly symbolizing a hair style, and
unexplained leg-like appendages alongside
the mouth. This combination of iconograph-
ic elements lends an ethereal feeling to these
works, further enhancing their ancestral
powers.

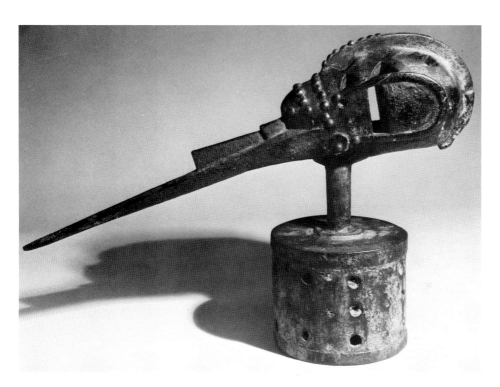

37
Ritual Bird (*Anok*)
Baga, Guinea
Wood & Brass Nails; 18″ (45.72 cm.); 1958

The Baga, one of the smallest tribes in Af-
rica, live in southwestern Guinea and are
primarily known for their large *nimba* head-
dresses (plate 1). However, of equal impor-
tance to the *Simo* secret society are the
anthropomorphic, two part sculptures re-
sembling a bird (*anok, elek,* or *atyol*).
These sculptures are said to be the protective
spirit of the *Simo* society and are carried to
the fields for ceremonies at the beginning of
the planting season. This figure, with its
heavy ritual encrustations, is of an older
style than the more elaborately carved and
decorated ones that have begun to appear in
recent years.

38
Face Mask (*Ma*)
Gio, Liberia
Wood & Metal; 8¾" (22.22 cm.); 1972

Usually attributed to the Dan, this type of
mask probably belongs to the Gio of eastern
Liberia, once functioning within the wide-
spread social institution known as *Poro*.
There are a tremendous number of face
masks in the society, each having a specific
name and use. Naturalistic masks with round
eyes such as this example are usually re-
garded as males, and function according to
their age and purpose within a specific rank
of the *Poro*. They exist in marked stylistic
contrast to the so-called Ngere masks (plate
39), but seem to operate within the same
basic institutions. *Poro* leaders wearing these
masks arbitrate disputes, collect taxes, pro-
tect villages from fires, punish criminals and
are responsible for training young male
initiates for admission into the society. This
particular type of mask was used to conceal
initiates in the secluded "bush school."

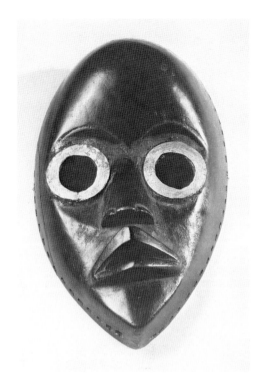

39
Bush Spirit Mask
Ngere, Ivory Coast
Wood & Fibers; 20" (58.8 cm.); 1952

Although this particular mask probably falls
somewhere between the classic Dan and
Ngere styles, its aggressive and dramatic
features, combined with horns and move-
able jaw, indicate that it is most likely a bush
spirit mask of the Ngere or their close neigh-
bors, the Kran. Masks of this type represent
a powerful bush spirit and dancers appear
completely covered by a raffia garment, a
fact which again reinforces the mask's con-
nection with the mysteries of the jungle.

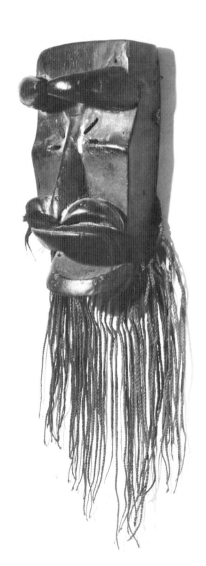

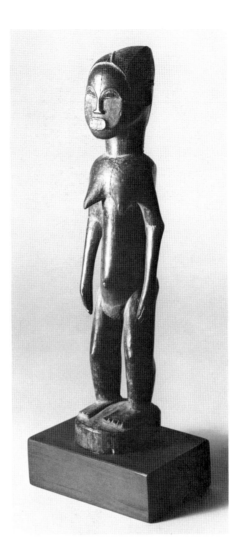

40
Female Figure
Baule, Ivory Coast
Wood; 13½" (34.29 cm.); 1959

According to some authorities, all figures produced by the Baule are thought to be personal ancestor figures, kept in the home where they receive prayers and appeals for good fortune. There are also larger carvings which serve as ancestor figures for the entire village. The Baule usually carve very symmetrical figures which are elegant, but somewhat static in feeling. This figure, however, with its asymmetrical headdress, is quite unique and seems to emote a power beyond the ordinary.

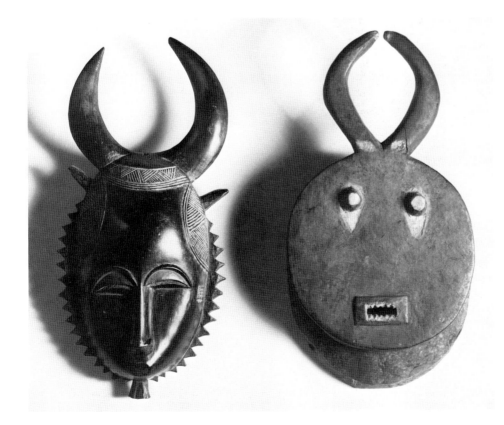

41
Face Masks (*Gba gba & Kplekple*)
Baule, Ivory Coast
Wood & Paint; 14" (35.56 cm.), 14¼" (36.83 cm.); 1952, 1971

The Baule are the western-most Akan-speaking group, living in the central Ivory Coast where they migrated during the 18th century. Although like their Akan relatives they are skilled metal workers, they are also masterful carvers, well known for their attention to detail and refined finish. The humanoid mask with animal horns is probably a *gba gba* mask from the Yaure subgroup of the Baule. According to Vogel (1973), the *gba gba* are animal/human face masks which are used in didactic skits explaining the world order of the tribe. The round, abstract *kplekple* mask is said to dance for the *Guli* society and represents an aspect of the sun. A combination of human and animal features, it dances through the village in order to avert evil.

42
Pendant
Baule, Ivory Coast
Gold; 3¼" (8.25 cm.); 1968

Although the Baule left the gold producing area of modern Ghana in the 18th century, they continued to be fine metallurgists and traded with their eastern Akan relations for gold. The Baule are well known for their exquisite pendants, cast in the lost wax method. Pendants in the form of a human face with beard and downcast eyes probably represent the spirit of *Gu*, the ruler of the world. They were worn only by the very wealthy.

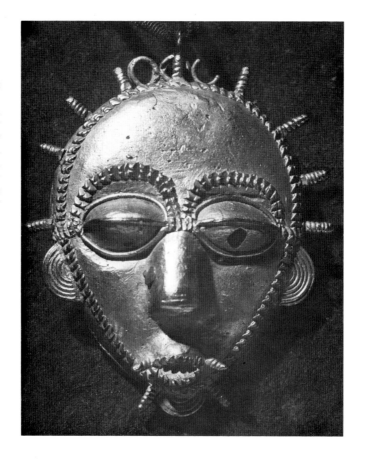

43
Seated Figure
Ashanti, Ghana
Wood, Paint & Kente Cloth; 15½"
(39.37 cm.); 1970

The Akan-speaking Ashanti are the politically dominant group in Ghana, being ruled by an *asantehene* and a large hierarchial court. The mythical sanction for this centralized state is a golden stool, which is the soul of the nation. All other chiefs have lesser stools which, in turn, symbolize their powers within the hierarchy. This finely carved figure sits on his stool of office wearing a leather covered amulet and a gown of silk cloth called *kente*. The piece certainly refutes the allegation that the Ashanti are wood carvers of little importance.

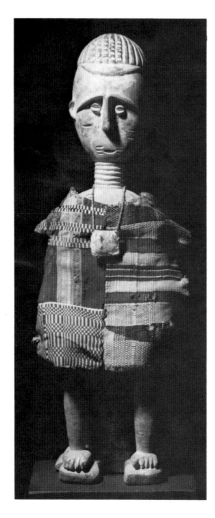
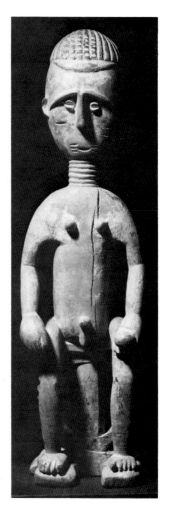

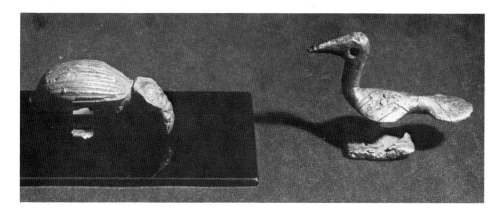

44
Bird & Beetle Goldweights
Akan (Ashanti?), Ghana
Brass; 1½" (3.81 cm.), 7/8" (2.13 cm.); 1973

The area inhabited by the Ashanti was formerly called the Gold Coast for it was the area of largest gold production in West Africa. The power and prestige of the Ashanti depended upon their control of the gold trade, and the power of the *asantehene* (king) was based upon the royal monopoly of gold. Gold was measured on scales and brass weights were used as counter-balances. These weights took many forms (geometric, figurative, and realistic) and most were associated with a proverb. For example, the beetle weight seen here recalls the proverb, "I am hungry as a beetle" (Menzel, 1968). The weights were all cast in the *cire-perdue* (lost-wax) technique. The weights of the king were always heavier, providing a means of royal taxation.

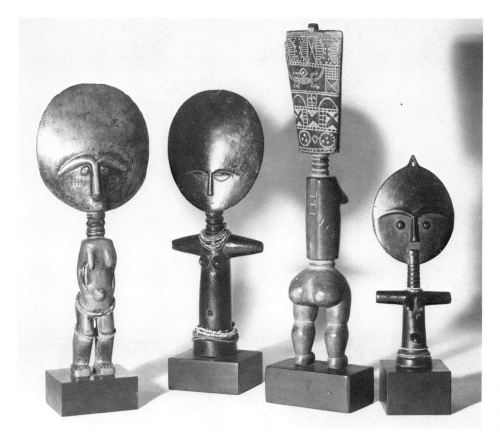

45
Female Figures (*Akua-ba*)
Ashanti & Fanti, Ghana
Wood & Beads; 13½" (34.29 cm.), 13¼" (33.65 cm.), 16" (40.64 cm.), 9 5/8" (24.45 cm.); 1965, 1968

Akua-ba are wrapped in a length of cloth and tied onto the back of an expectant woman where they are thought to influence the beauty of her forthcoming child. The Akan believe that the head is the place of utmost beauty and that its shape should be as perfect as possible. Although we have here two examples with finely articulated bodies, such figures are usually depicted without legs so as to keep the head the focus of attention. The figure with the rectangular head is Fanti, an Akan group closely related to the Ashanti. Such figures serve the same function as their Ashanti counterparts, although the aspect of beauty (shape of the head) is quite differently conceived. It is not surprising that all *akua-ba* figures are female, as the Akan are a matrilineal group.

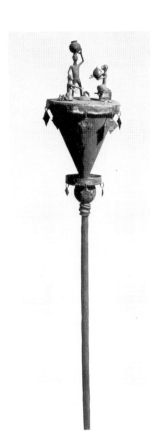

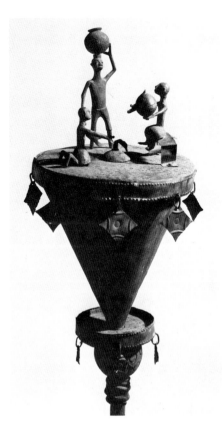

46
Altar Staff (*Asen*)
Fon, Dahomey
Iron & Brass; 41" (104.14 cm.); 1971

The Fon, another centralized state, live in central Dahomey and are the only major sculpture producers in that area. Their main artistic production, however, consists of brass figures which are cast by a guild that is supported by the patronage of the king. The *asen* are made from forged pieces of iron sheeting surmounted with cast figures. They are used to symbolically feed the ancestors and are placed together in groups on special polychrome mud altars. The figures on the top of this *asen* are apparently performing some type of ritual; possibly the feeding of the ancestors.

47
Fetish Figure
Fon, Dahomey
Wood, Iron, Leather & Bone; 17" (43.2 cm.);
1974

According to Fagg (1970), fetish figures such as this example are often sworn upon to determine a person's innocence or guilt. However, the range of uses to which fetish figures are put is so great that the function of any specific one cannot be definitely established. This piece, with smaller wooden figures bound around a central larger one and the attached animal skull at the base must have had a very powerful function.

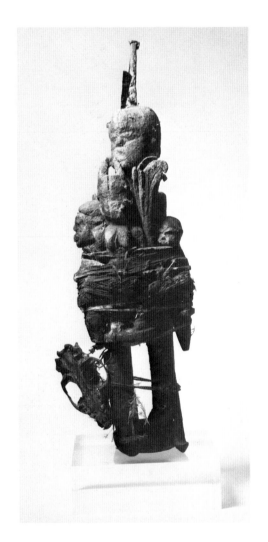

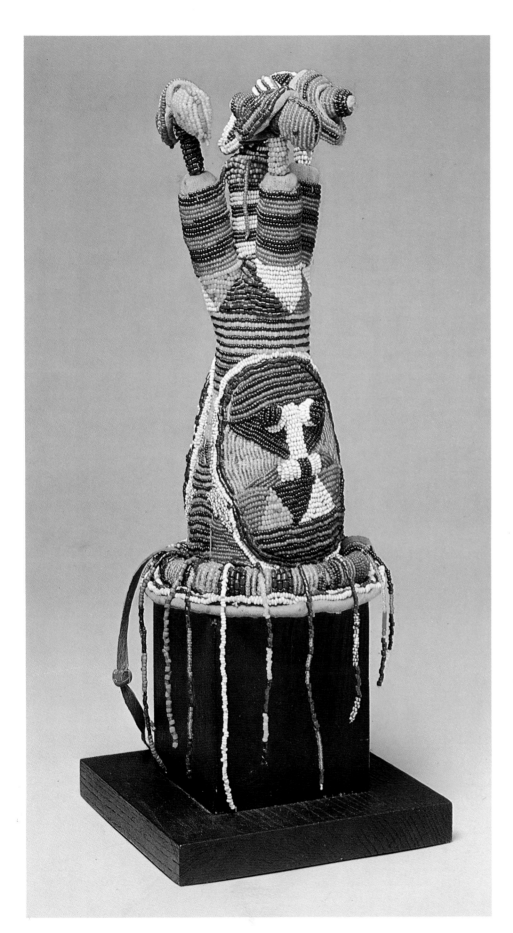

48
Chief's (*Oba's*) Crown
Yoruba, Nigeria
Cloth, Beads & Leather; 11" (27.94 cm.);
1952

The Yoruba, perhaps the largest tribe in
Africa, have lived for centuries in urban
settlements under the rule of kings (*obas*) and
their elaborate courts. Yoruba legend recalls
how the creator, *Oduduwa,* sent his sixteen
sons to establish the Yoruba kingdoms. Each
son was given a beaded crown, a tradition
that exists to this day and one which enables
all Yoruba kings to theoretically trace their
power back to the original ancestors. The
face on the crown is surmounted with three
columns topped with birds, suggesting
magic aerial communication with the gods.
The birds might also symbolize the king's
power over evil (birds of the night are con-
sidered witches). The beaded veil hanging
from the crown covers the chief's face, there-
by separating him from this world and
allowing him to manifest the dynasty begun
by the first ancestors.

49

49

Staffs (*Opa Orere* and *Opa Osanyin*)
Yoruba, Nigeria
Iron; 49" (124.46 cm.), 27½" (69.85 cm.),
19½" (49.53 cm.); 1972, 1974

These iron staffs function as sacred emblems
for the tribe's herbalists and diviners. The
herbalist's staff (*opa osanyin*) symbolizes the
herbalist as a large bird dominating sixteen
(the number of original ancestors) lesser
birds or witches. The diviner's staff (*opa
orere*) is distinguished by the appearance of
four bells over which the large bird (diviner)
dominates. The bells represent the medicinal
plant used in preventing witchcraft. The
many symbolic levels on which these staffs
can be interpreted are a small indication of
the complex mythology surrounding man's
power over the supernatural.

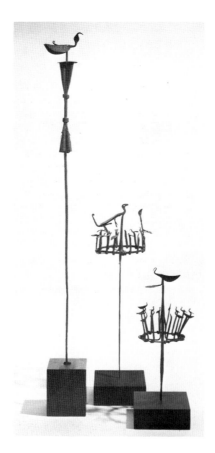

50

Ancestor Figures
Mumuye, Nigeria
Wood & Paint; 32¼" (81.91 cm.), 35½"
(90.17 cm.), 27½" (69.85 cm.); 1973

Although earlier publications indicate that
figures of this type are from the Chamba,
Rubin (1969) has clearly placed them among
the Mumuye tribe who live just south of the
Benue River in east-central Nigeria. These
figures, with their vibrating surface planes
and wonderfully fluid arms, are said to rep-
resent ancestors who have the power to
bring rain and ameliorate crisis situations.
Fagg (1970) states that these figures represent
dead parents and are kept in the homes of
living relatives to aid in difficult situations.

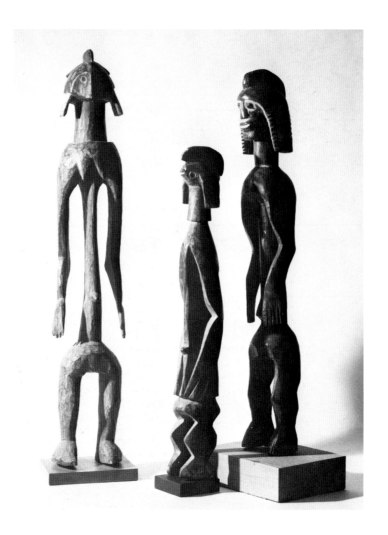

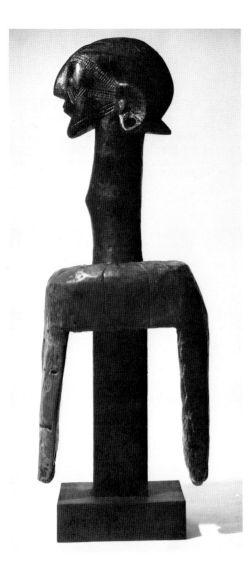

51
Dance Headdress (*Wunkur*)
Jukun, Nigeria
Wood & Oil; 34" (86.36 cm.); 1973

According to Rubin (personal communication with Loran, 1973), this headdress or yoke is called *wunkur* and comes from the Jukun village of Kona, south of the Benue River. The headdress is normally kept in a special shrine where it is anointed with palm oil to ensure its power. The headdress is also danced annually to announce the year's most important harvest festival. The *wunkur* is covered from the neck down by a raffia garment which is designed to hide the identity of the dancer. The top of the head is decorated with feathers. According to Leuzinger (1972), similar headdress types are also found among the Waja, close neighbors of the Jukun in the Benue area.

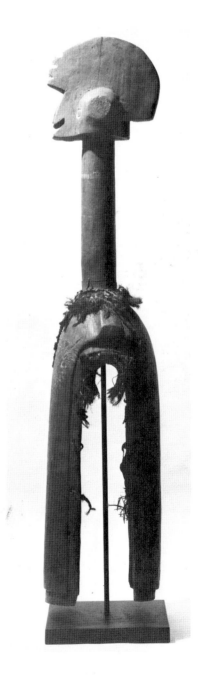

52
Dance Headdress
Wurkun (?), Nigeria
Wood & Fibers; 67" (170.18 cm.); 1972

This huge headdress or yoke comes from one of the least documented areas in Nigeria. Arnold Rubin (personal communication with Loran, 1973) indicated that this piece probably comes from the area just north of the Benue River around Jalingo or Niano, although he was not aware how the object was used. The present writer tried to wear the headdress and could comfortably support the piece on his head. There are, however, no holes to look through. Judging by the remnants of raffia, the sides must have been covered, leading one to conclude that the dancer was either led around or danced in an unobstructed, open area. Rubin (personal communication, 1974) suggests that the dancer may have been positioned between two drummers and was possibly guided by the sound of the drums.

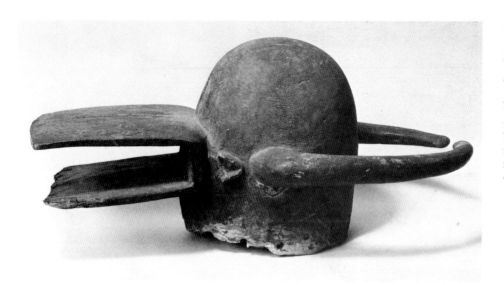

53
Zoomorphic Helmet Mask
Chamba, Nigeria
Wood; 13" (33 cm.); 1974

The Chamba live to the southeast of the Jukun on the Jos plateau. According to Leuzinger (1972), simple but powerful zoomorphic masks like this may represent the benevolent spirit of the bush cow. These masks are placed on the dancer's head at a forty-five degree angle while his body is concealed with a covering of bast.

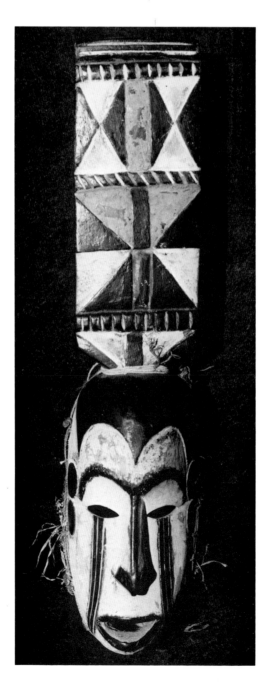

54
Female Face Mask (*Mma*)
Igbo (Afinkpo), Nigeria
Wood, Paint & Raffia; 18" (45.72 cm.); 1971

The Igbo, eastern neighbors of the Yoruba and Bini, live in the northern delta areas of the Niger River. They are a loosely knit group and show great regional variation in their artistic production. The Afinkpo, the northeastern group of the Igbo, have been well-documented by Simon Ottenberg's field work. A wide range of mask types (several similar to this example) are used in skits at the *Okumkpa* festival and are produced by the young men of the village. The skits entertain, while re-establishing social harmony by publicly satirizing deviant or improper behavior. Although the masks themselves do not represent very powerful spirits, they do symbolize the totality and continuity of the past as established by the ancestors.

55
Face Mask
Ibibio, Nigeria
Wood & Paint; 11 1/8" (28.26 cm.); 1951

The Ibibio, the southern neighbors and tra-
ding partners of the Igbo, live near the
mouth of the Cross River. They are ruled by
the powerful *Ekpo* secret society which
dominates all aspects of village life. This
beautifully conceived mask depicts the high-
est member of the *Ekpo* society (*idiong*),
symbolized by the circular marks on the
temples. The stylized beard also refers to the
member's age and seniority. The serene
expression conveys the consummate wisdom
and total harmony of the *idiong*.

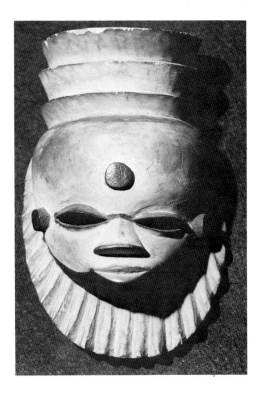

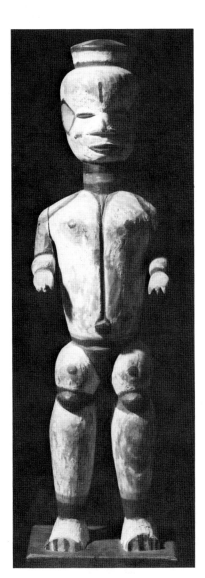

56
Female (?) Figure
Ibibio, Nigeria
Wood & Paint; 17 1/8" (43.50 cm.); 1952

This figure shows a close resemblance to
Igbo carvings, but retains the characteristic
Ibibio feature of separate appendages. Par-
inder (1967) attributes figures of this type to
the *Ekpo* society whose function is to pro-
pitiate the ancestors and insure fertility. This
figure is a masterpiece of carefully controlled
forms, the expression giving the impression
of serenity and stability, yet conveying tre-
mendous, latent power in the flexed body
stance and taut, smooth surface.

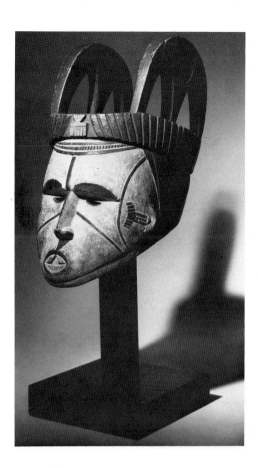

57
Helmet Mask
Igala, Northern Nigeria
Wood & Paint; 18½" (47 cm.); 1974

The Igala inhabit the area east of the Niger and south of the Benue River. Although little is known of their past, linguistic and cultural evidence points to a common though ancient origin with the Yoruba and Idoma, while the Igala ruling group claims descent from the Wukari Jukun. There are also indications of early contacts with Benin. The sculpture of the eastern Igala groups seems to have incorporated a number of influences from the neighboring Idoma, Igbo and Afo. This elegant helmet mask is probably eastern Igala and may have been worn in a ritual to honor the dead.

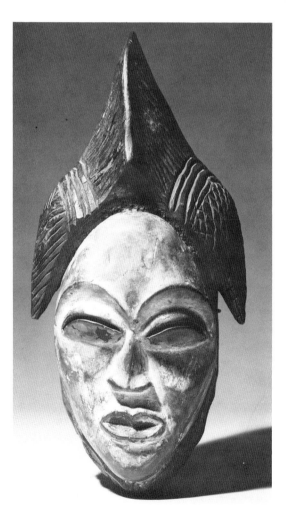

58
Face Mask
BaLumbu, Gabon
Wood & Paint; 15" (38.1 cm.); 1952

The BaLumbu are a small group living along the Ogowe River. Because masks of this type occur among several related groups, exact attribution is unknown. Nevertheless, this type of whitened mask represents a beautiful girl although it is worn by a man during ceremonies of the *Mukui* secret society. The masquerader represents the spirits of the ancestors and dances to invoke their help for the living. The *Mukui* initiate wears this mask with a long raffia and cloth costume and dances through the town on stilts. The stilts remove the spirit from direct contact with the earth and the narrow slit eyes prevent the spirit of the ancestors from entering the body of the dancer and causing harm.

59

Face Mask
Ogowe River Area, Gabon
Wood, Paint & Fibers; 19″ (48.26 cm.); 1955

Although face masks of this type are clearly from the Ogowe River area, it is difficult to assign them precisely to any specific group. Fagg (1969) attributes them to Mitsogo, while Leuzinger (1963) indicates they are from the Kota and represent the face of an ancestral spirit seen in a dream. In either case, their function is to drive away witches and thus purify the village. This mask has only traces of its original paint remaining but it was undoubtedly painted black and white, the colors of the ancestral spirits.

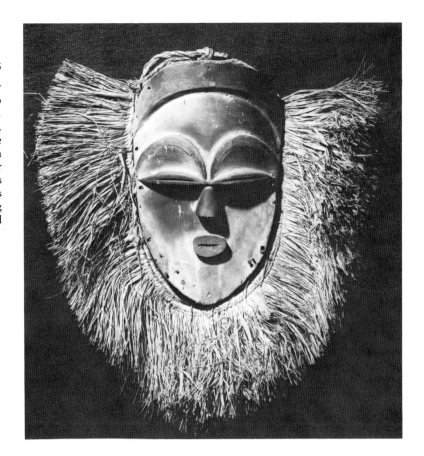

60

Reliquary Figure (*Mbulu ngulu*)
Kota, Gabon
Wood, Brass & Copper; 22½″ (57.15 cm.); 1952

The Kota and related groups are famous for their reliquary guardian figures known as *mbulu ngulu* (image of the spirit of the dead). Although the available information is sketchy, most authorities concur that these figures were placed on the top of a box containing the bones of outstanding ancestors (*bwiti*). Such figures are believed to ward off supernatural intervention, particularly witchcraft, aided by the powers of the *bwiti*. The elaborate brass covering is a symbol of wealth, but the brass also reflects light (sun and fire) and might be part of the force used against witchcraft. A family's *bwiti* with the *mbulu ngulu* on top is occasionally brought together with all the others in the village to renew the strength of the entire village with ancestral power.

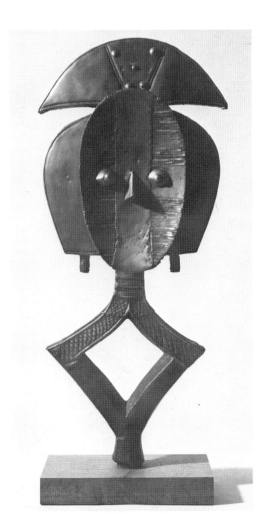

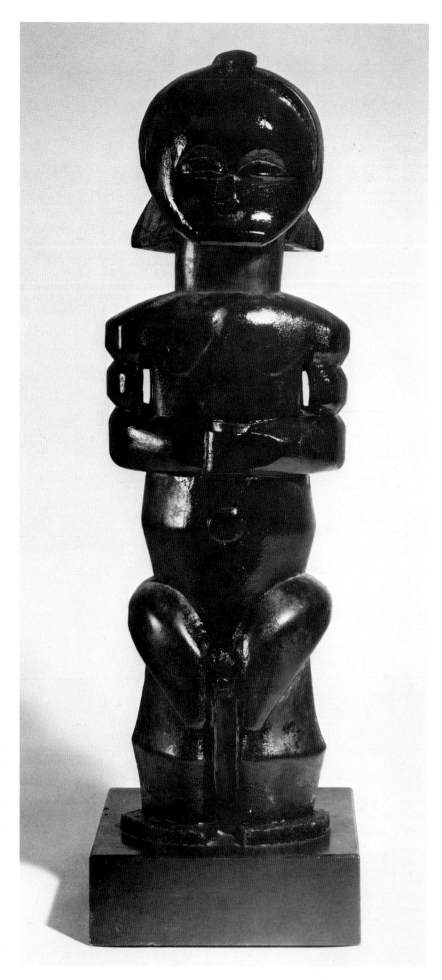

61
Reliquary Figure
Fang, Gabon
Wood & Oil; 19¼" (48.89 cm.); 1950

The Fang, close neighbors of the Kota, utilize very different sculptural forms to protect the bark containers (*bieri*) which house the bones of important ancestors. These highly controlled figures have a pole down their back which fits into a hole in the top of the *bieri*, securing the figure in an upright position. The muscular tension and strength, as well as the gleaming surface, are the necessary forces to ward off evil interference. The *bieri* are normally kept on a family altar, rubbed with oil, and given sacrifices every morning to insure their continual power. During initiation ceremonies, the leader of the secret society brings out his *bieri* to allow the ancestors to participate in the celebration—thus enhancing both the ancestors and his living relatives' prestige.

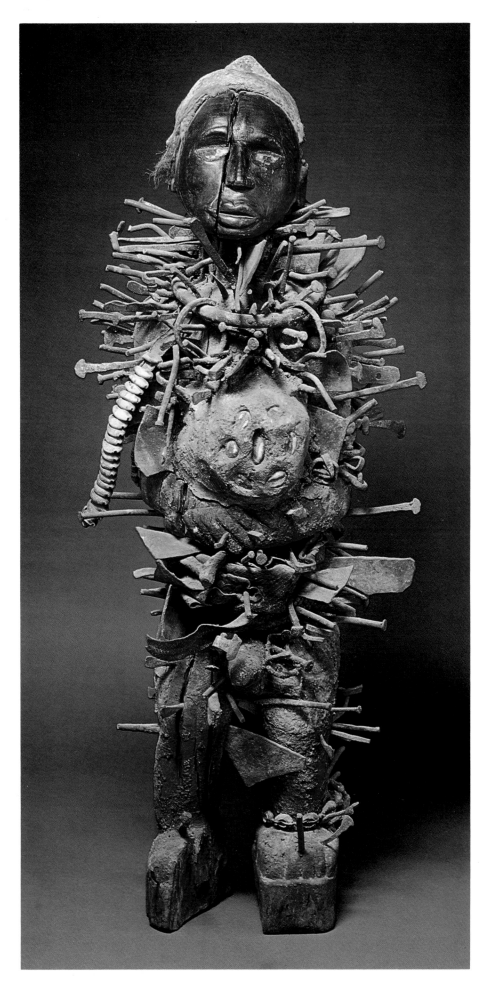

62
Nail Fetish (*Nkisi*)
Kongo, Zaïre
Wood, Cloth, Nails, Mirror, Clay & Hide;
31½" (80.01 cm.); 1970

The Kongo, a large and ancient tribe living at the mouth of the Congo River, are well known for their terrifying nail fetishes. These *nkisi* represent a spirit or soul of an ancestor, but their function seems to be ambivalent. Most accounts indicate they are malevolent images, kept by witch doctors and activated by driving in a nail which can direct illness and/or other misfortunes upon an enemy. But there are also reports (Volaukova, 1972) that the *nkisi* function as benevolent figures, used to cure illness and prevent misfortune. These multiple interpretations point to the difficulty in assigning a piece one function, when, in fact, it might have several different uses depending upon societal needs. The reflection from the mirrors on the abdomen and in the eyes are thought to insure that no one can see into the power of the fetish. This *nkisi* was formerly in two Dutch collections and was first acquired in 1936.

63
Seated Male Figure
Bembe, Zaïre
Wood; 5 1/8" (13.02 cm.); 1952

The Bembe, living west of Brazzaville on the Niari River, were once part of the Kongo kingdom, a fact which is reflected in their sculptural style. Figures such as this function as charms or fetishes, deriving their power from magical substances that are often inserted into an anal orifice. These figures are also characterized by elaborate tribal scarification marks along the abdomen. The inlaid eyes seem to intensify the controlled gaze of this particular figure, giving him an even more menacing appearance.

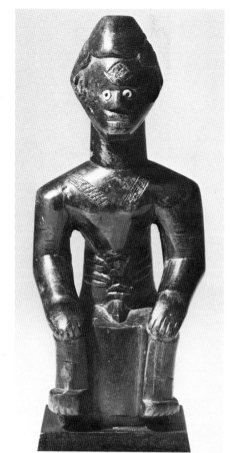

64
Pendant (*Minyaki*)
Pende, Zaïre
Ivory; 2½" (6.35 cm.); 1951

The Pende, a large tribe living in southwestern Zaïre, are well known for their polychrome wooden masks used in *mbuya* plays. Less common, but equally important, are the small ivory *minyaki* pendants which are worn by young male initiates to denote their successful and complete initiation into the society. These small faces are copies of the great ancestral mask and derive their power and protective qualities from this association. The tri-pointed headdress and beard are symbolic of this great ancestor and further energize the mask with sacred ancestral power.

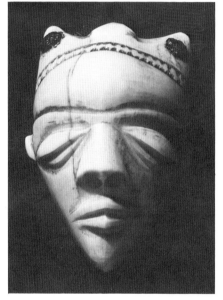

65
Staff Top
Pende, Zaïre
Wood; 9 3/8" (23.8 cm.); 1974

The Pende produce few figure sculptures except those on top of staffs. It is most likely that this figure once adorned the top of a staff used by chiefs as a symbol of their power and presence and by orators who struck the ground with the staff, to emphasize a point. Sousberghe (1958) calls them *"cannes de palabre"* referring to their use in verbal disputes between various clans or clan members. The Pende refer to these staffs as *mihango* and they occur only among the western Pende.

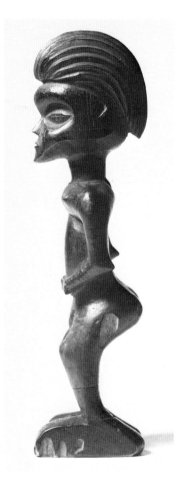

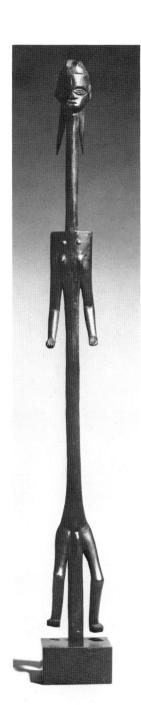

66
Female Staff
Mbuun, Zaïre
Wood & Metal; 33" (83.82 cm.); 1955

According to Dr. Maesen (personal correspondence with Wm. Bascom, 1967), the Mbuun (Mbunda) are close neighbors of the Pende and Bachilele and live near the Loange River. Staffs of this type were used by the heads of localized lineage segments during judicial procedures. They are presumably symbols of the power and prestige of these family leaders. This elegantly graceful figure is one of the finest known examples.

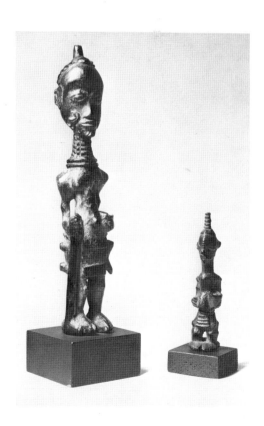

67
Female Figures (*Lupfingu*)
Bena Lulua, Zaïre
Wood; 10¼" (26.03 cm.), 5¼" (13 cm.); 1952, 1974

The Bena Lulua live in the south-central Congo River basin near the edge of the Dibese forest. *Lupfingu* figures (sometimes called *mbulenga*) are their most common type of figure sculpture and play an important role in magical religious practices. The left hands of these figures hold a bowl which probably once contained magical ingredients. The elaborate tribal scarification patterns are accentuated by the application of *tukula* powder. Because the Lulua were matrilineal until the late 19th century, some authors believe these figures to be ancestral.

68
Lidded Boxes
Kuba, Zaïre
Wood; 4" (10.16 cm.), 2¾" (6.98 cm.); 1955

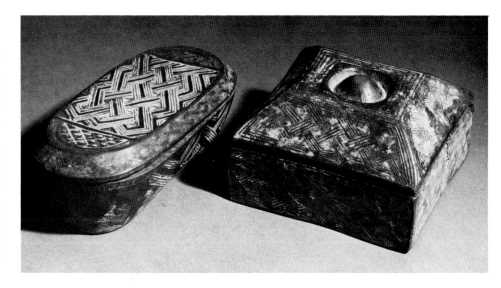

The Kuba are one of the best documented groups in Africa. They formed a political confederacy of considerable size and strength in the 17th century, uniting various tribes in the central Congo Basin under their rule. The Kuba are prolific sculptors, and, as a sign of prestige, decorate even their most utilitarian objects. Lidded wooden boxes are common and are generally used to contain a cosmetic powder, *tukula*, which is ground from a red wood (*Pterocarpus*). The *tukula* is mixed with palm oil and is used as a cosmetic body paint. The incised designs on these containers are patterns taken from the woven raffia cloth known as kasai velvet.

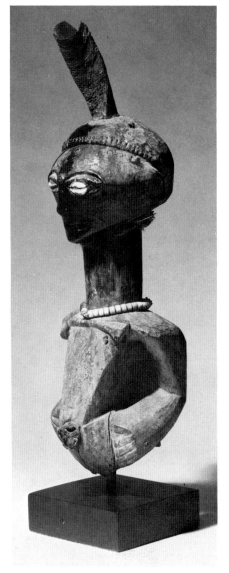

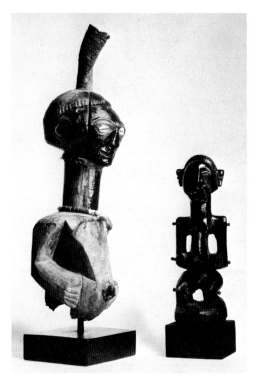

69
Fetish Figures (*Buanga*)
Songe, Zaïre
Wood, Shell, Horn & Beads; 18" (45.72 cm.), 10½" (26.7 cm.); 1968, 1974

The Songe, a large group living in east central Zaïre, have a reputation for being aggressive warriors. Magic is very important to the Songe and they are perhaps Africa's most prolific fetish-makers. Usually benevolent, the fetishes are used for protection against evil forces and witchcraft. The figures are sometimes owned by the entire community and are kept in a fetish house at the center of the village. Other smaller fetishes are owned by individuals. The magical substances (*bijimba*) which give the fetish its power are inserted in the horns or in cavities on the top of the head or in the stomach. These figures are often clothed from the waist or shoulders down. The example on the left was obviously clothed from the shoulders down, as only the head and neck portions bear the traces of sacrificial oils.

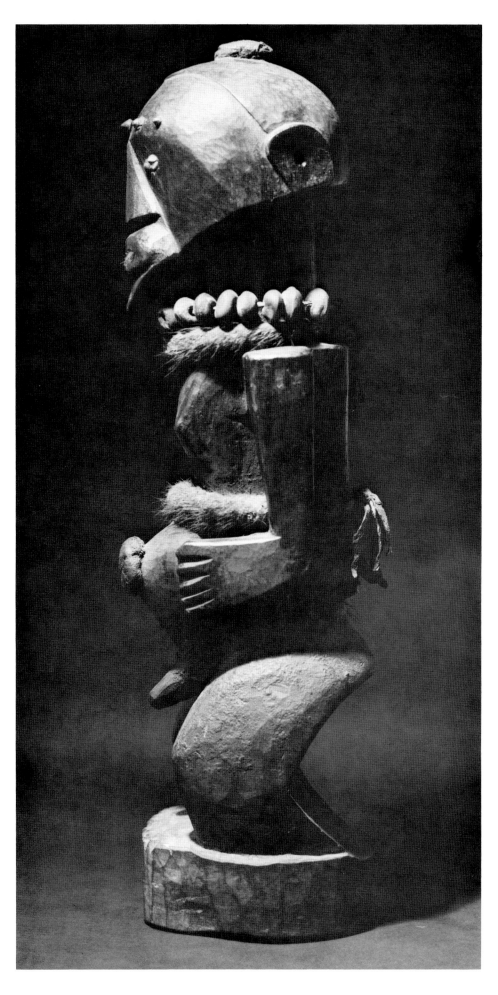

Fetish Figure (*Buanga*)
Songe, Zaïre
Wood, Fur & Shells; 30'' (76.2 cm.); 1955

Similar in origin and function to plate 69, this figure has magical substances inserted in head and stomach cavities. Stylistically, this fetish is typical of the classically aggressive Songe type. Aside from their power to avert evil, these *buangas* are also thought to aid in fertility and ensure perfect children. The power of the figure is accentuated by the shell necklace and additions of fur around the waist and neck.

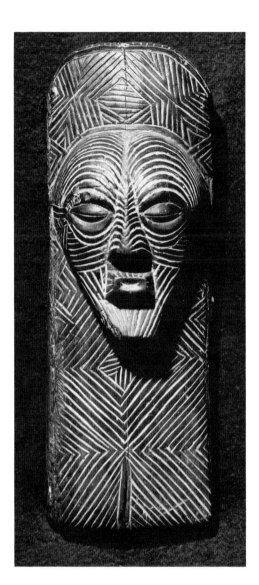

71
Plaque with Mask
Songe, Zaïre
Wood; 15 1/8" (38.42 cm.); 1952

Objects such as this have been documented as shields for the warlike and aggressive Songe. However, the diminutive size of this object and the lack of any carrying apparatus suggests that it was not used in this manner. The distinctive face recalls the mask type belonging to the *Kifwebe* secret society, and it is possible that this object had some ritual use within the *Kifwebe* initiation camp.

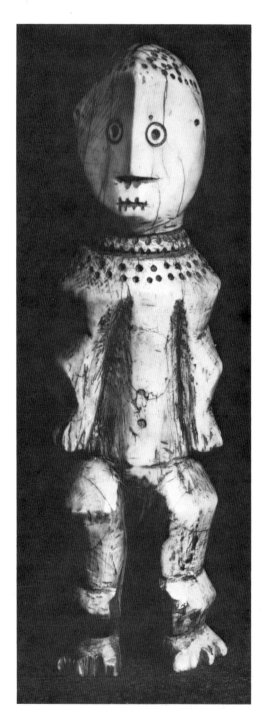

72
Ivory Figurine (*Iginga*)
Lega, Zaïre
Ivory; 6 5/8" (16.8 cm.); 1974

Occupying the tropical rain forests of eastern Zaïre, the Lega produce a variety of ritual objects for use in *Bwami*, an elaborately organized mens' association based on numerous hierarchical grades and subdivisions. Advancement in *Bwami* represents spiritual and moral excellence which Lega men view as the ultimate human achievement. Ivory figurines such as this example are associated with the higher *Bwami* grades and are displayed, danced, or contemplated during important rites such as initiation. They are also placed on the grave of their deceased owner. A man's prestige is measured by the number of figurines in his possession and each figurine is associated with at least one proverb. The yellow patination on this piece is the result of years of purposeful beautification.

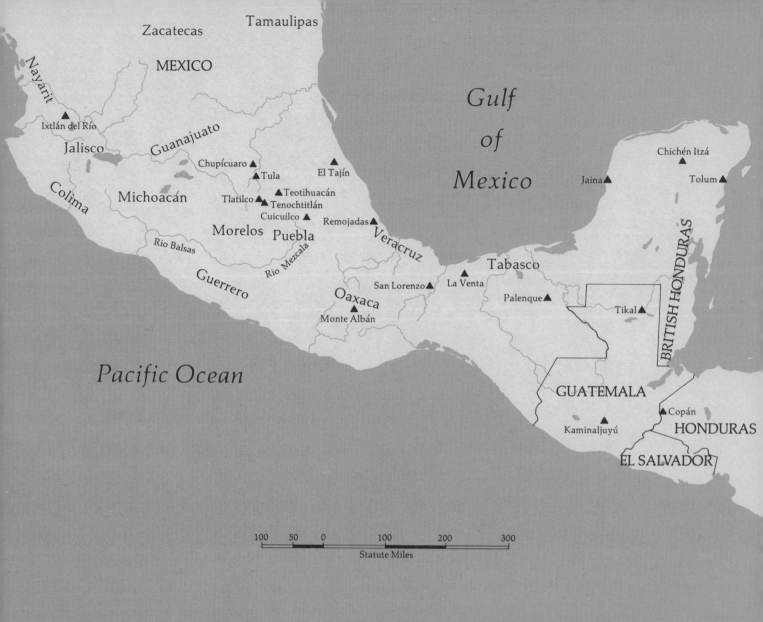

Zacatecas

Tamaulipas

MEXICO

Gulf

of

Mexico

Nayarit

▲
Ixtlán del Río

Jalisco

Guanajuato

Chichén Itzá ▲

Chupícuaro ▲

El Tajín

Jaina ▲

Tolum ▲

Colima

Michoacán

▲ Tula

Tlatilco ▲ ▲ Teotihuacán
▲ Tenochtitlán

Cuicuilco ▲

Morelos Puebla

Remojadas ▲

Veracruz

BRITISH HONDURAS

Rio Balsas

Rio Mezcala

Tabasco

Guerrero

Oaxaca
▲
Monte Albán

San Lorenzo ▲

La Venta ▲

Palenque ▲

Tikal ▲

Pacific Ocean

GUATEMALA

Kaminaljuyú ▲

▲ Copán

HONDURAS

EL SALVADOR

100 50 0 100 200 300

Statute Miles

Ancient Art of Mexico: Death and the Ancestors
By Jane Powell Dwyer
 Edward Bridgman Dwyer

The art of the ancient peoples of Mexico has long attracted and fascinated the cultural historian interested in developing some kind of insight into the lives of its producers. These works have also received attention from modern artists and collectors of art because of their powerful aesthetic appeal. Although the Loran Collection was assembled on purely aesthetic grounds, a significant degree of understanding of ancient cultures can be achieved by reflection on this group of Precolumbian sculptures.

Before considering the objects themselves, it will be useful to have some understanding of the general outline of Mexican cultural development. The prehistory of Mexico may be viewed on two axes for ease of comprehension. We can first consider time and follow the generally accepted chronological divisions of Preclassic (2000 BC - 300 AD), Classic (300 AD - 900 AD), and Postclassic (900 AD - 1520 AD) periods. These temporal stations apply everywhere and do not necessarily reflect the level of cultural development in a specific region. If we compare the Classic Veracruz and Classic West Mexican cultures, we are talking about different areas with differing cultural complexity at approximately the same point in time. The use of the word "classic" as a temporal marker is an anachronism explainable in the peculiar history of the terminology of Mexican archaeology.

The second axis is geographical. There were and still are great regional variations in Mexican culture and art. Developments took place early in one area or late in another, sometimes as a result of contact and trade between areas and sometimes independently. In this catalogue we try to indicate the modern state from which a particular piece derived. Still, it is important to conceptualize larger areas which seem to have developed as units and within which there appear to be large numbers of shared cultural systems. Here, we will consider West Mexico (Nayarit, Jalisco, Colima, Michoacán, Guanajuato, Zacatecas and parts of Guerrero), Central Mexico or the Central Highlands (Mexico, Morelos, Puebla, Tlaxcala, Hidalgo, Querétaro) and the Gulf Coast (Tabasco, Veracruz, and parts of Tamaulipas). These are the three culture areas from which most of the objects in the Loran Collection derive.

Let us first consider these objects in terms of their general chronological orientation within Mexican prehistory. The Preclassic period (2000 BC - 300 AD) was a time of experimentation, innovation and development which set the pattern for the later, sophisticated civilizations of the Classic period. Archaeological evidence indicates that Preclassic settlements flourished in many parts of Mexico, as well as in Guatemala and the other adjacent regions of Mesoamerica. These were communities of farmers who cultivated corn and other crops, supplementing their food economy by hunting and fishing. The Preclassic was also a time of significant artistic development in which techniques of pottery-making and weaving were perfected and, in a number of areas, major efforts were made toward elaborate forms of ceremonial architecture.

The most advanced Preclassic culture was that of the Olmecs whose main religious centers were built in the tropical Gulf Coast lowlands but whose influence was felt throughout much of Mesoamerica. As early as the 14th - 13th centuries BC, the Olmecs began to build spectacular ceremonial centers comprising earth mounds, pyramids and wide plazas. Over the next several centuries, these Gulf Coast Olmec sites were a focus of artistic production and ritual activity. At a number of these centers, enormous sculptured stone monuments were erected on or buried within the earthen mounds. Smaller sculptures made for ritual or funerary purposes and ornaments worn by the priestly hierarchy were carved from precious materials imported from distant regions.

Olmec influence was felt in many parts of Mexico—the Central Highlands, Oaxaca, Puebla, Morelos and Michoacán. Even as far as southern Guerrero on Mexico's Pacific coast, Olmec-style clay figurines are abundant and are sometimes found associated with large earth mounds. In the Rio Mezcala and Rio Balsas regions of Guerrero, there is a long tradition of carving small figures, masks and ornaments from hard stone. The earliest of these sculptures bear unmistakable Olmec-style attributes.

How Olmec-style forms and concepts were transmitted is not yet known, but trade, missionary activity and even warfare have been surmised. In the Central Highlands, these influences had a strong impact on the simple Early Preclassic farmers of the Valley of Mexico; in fact, some archaeologists believe that Olmec migrants or invaders may have actually lived among the indigenous folk.

By about 900 BC in Middle Preclassic times, Olmec prestige in the Central Highlands seems to fade. In settlements around the shores of Lake Texcoco, new styles of elaborately shaped pottery vessels and delicately modelled figurines have been found. In the village cemeteries at Tlatilco, some individuals were buried with great quantities of these figures (plate 73) and pottery offerings while others were provided with very few or none at all. The figurines, which were modelled in a wide range of forms and poses, have also been uncovered in the ancient household rubbish heaps, indicating that they were probably utilized in day-to-day ritual observances as well as for funerary purposes, perhaps indicative of a close involvement between the dead and the living.

The Late Preclassic saw the growth of large and important settlements such as Cuicuilco in the Valley of Mexico and the emergence of what would become the great city of Teotihuacán. Also at this time, significant ideas of style in pottery and figurine manufacture were spreading from a new center of artistic activity farther west at the site of Chupícuaro in Guanajuato and related communities in nearby Michoacán. Distinctively bright polychrome ceramics were characteristic of the Chupícuaro style (plate 75) and figures and pottery vessels in unusual shapes (plates 74-77) were much admired and traded throughout the highland regions. However, most were primarily manufactured for local use as burial offerings. Burials richly provided with these ceramics have been excavated along with evidence of elaborate mortuary procedures which apparently included sacrifical burning or ritual fires.

Chupícuaro may provide a link between Central Mexico and the lesser known, very distinct cultures of West Mexico. In West Mexico, particularly Nayarit, Jalisco and Colima, preoccupation with the dead was even more intense. These peoples were unique in their construction of shaft-chamber

tombs usually excavated to the depth of a substratum of volcanic tuff in the earth, sometimes as much as 15 meters deep. Apparently dictated by a complex mortuary cult, they interred their dead with numerous ceramic sculptures portraying much in the life they had known—human figures, animals, vegetables, inanimate objects—perhaps in an effort to provide another link between the world of the living and the realm of the ancestral dead. The height of this West Mexican death cult and the artistic productivity associated with it came during the Late Preclassic, although in some perhaps remote regions it continued into Early Classic times when West Mexico was finally drawn closer to the mainstream of Mexican civilization.

The Classic period (300 AD - 900 AD) is defined by the erection of dated stelae in the Maya lowlands (southern Mexico and northern Guatemala). It was also a time when Central Mexico became a dominant economic, political and religious power. The seat of this new power was the growing urban center of Teotihuacán. Located in an arm of the Valley of Mexico, Teotihuacán had become an important religious and ceremonial focus in Preclassic times. The early (Teotihuacán I) ruins consist of platform mounds and residences covering over three square miles. By Classic times (Teotihuacán II and III) there were more than 13 square miles of palaces, walled residential apartment houses and a carefully laid out central street flanked by numerous temples which were associated with two very large pyramids. At the south end of this "Street of the Dead" as it is called, was a large ceremonial compound containing raised temples and pyramids. Across the "Street of the Dead" was an open area, probably a vast central market.

Teotihuacán produced or controlled the supply of various economic goods. Different types of pottery, obsidian and carved stone, either manufactured at Teotihuacán or in Teotihuacán style, were traded to points as distant as highland Guatemala. One pottery type (Thin Orange), while probably made in Puebla, spread so widely with Teotihuacán influence that it is used as a time marker. A technological innovation, seemingly introduced in Teotihuacán III, was the use of molds to fashion small ceramic figurines by the thousands. Other important Teotihuacán art forms were intricately painted pottery vessels and wall murals, and carved human faces or masks of fine grained stone (plate 97).

On the Gulf Coast, the Classic cultures of Veracruz drew upon a rich Preclassic figurine tradition and began producing ever larger hollow ceramic sculptures of great technological and artistic achievement. Among the most interesting of these types are the so-called "smiling figures" (plate 101) from central Veracruz, usually associated with the site of Remojadas. These tomb figures are thought by some to represent an inebriated initiate to the spirit world, having partaken of a hallucinogenic substance and been prepared for sacrifice. Important stone sculpture was also produced at this time and is generally thought to be associated with the ritual ball game.

By Postclassic times (900 AD - 1520) the civilization of Teotihuacán had long fallen, the city having been sacked and burned by unknown peoples around 600 AD. But Central Mexico remained powerful with the rise of the Toltecs and, finally, the Aztec confederation. West Mexico was able to retain its independence under strong Tarascan leadership but the Gulf Coast came gradually under the sway of the Central Highlands until, at the time of the Spanish arrival, it was a tribute-paying auxiliary of the Aztec state.

Postclassic political conditions and population movements are interesting for what they tell us about the fall of Classic period civilizations. Groups of northern tribal peoples (the Chichimecs) began moving south in waves of migrations. Both the Aztecs, who became dominant in Central Mexico, and the Tarascans (Purépeche as they called themselves), who became dominant in West Mexico were nomadic peoples who settled in the midst of feuding remnant states. In both cases, by shrewd political manipulation and marriage alliances, they gained power and became "civilized" at the same time. Both groups eventually dominated their respective spheres and, emphasizing strong military power, fought to a stand-off in a series of wars in 1469-78.

In the Gulf Coast region, there was an early Postclassic Toltec intrusion, representing either the power of that central Mexican state or an actual shifting of a Toltec population to the Gulf Coast. Later, by the time of the Spanish arrival, a number of Gulf Coast cities were occupied by a well established group called the Totonacs who seem to have migrated into the area from Central Mexico after the time of Toltec power. Their capital at Cempoala had wide paved streets and great white temples. The Spanish also noted an elaborate system of underground canals bringing water to all parts of the city. It was a truly modern city in its day, yet its people, rebellious against their Aztec rulers, were won over by the Europeans (Torquemada, 1969: Vol. 1, 278-281, 396).

During all this time and over all this area art was being produced. But what remains today is only a small sample of that art—the durable pieces primarily of fired clay and carved stone. What do these objects reveal about their makers? What meanings did they hold and how were they used? We can only begin to answer these questions. Perhaps the most important consideration for the understanding of this art is its relationship with death and the spirit world. Much of the existing art is funerary art, sculpture placed in the tomb at the time of interment of the dead. If we place ourselves in the position of the maker and user, with the knowledge that this material may have been intended for the souls of the dead not for the living, we might then achieve a greater understanding. Granted, a good deal of Precolumbian art was produced to serve as luxury items, intended to signal and maintain social boundaries. There were also valuable goods made for trade, and objects designed for religious ceremonials. Still, much of the art we know today is composed of either funerary offerings or material which was most likely dedicatory to the gods, souls of the deceased, or the spirit world in general. As has recently been pointed out by Michael Coe (1973) for the Maya, the funerary aspect of Precolumbian art has all too often been ignored.

It is important then to consider how and why this kind of material was placed into the ancient graves but, unfortunately, this is a difficult task. We do know something of religion and burial customs especially for the Aztecs at the time of the European arrival in the New World. Also, recent ethnographic studies of present day western and northern Mexican tribal religions may give glimpses of ancient practices. Nevertheless, there is no sure way of establishing ancient ways of life by recent analogy. All we can achieve is a realization of the complexity of the problem.

In Aztec times, funerary ritual was elaborate. Different occupations and different kinds of death not only required different rituals but also directed the final destination of the deceased's soul. Death was not everlasting, but rather part of a necessary cycle. Warriors who died in battle or who were sacrificed became reincarnated as hummingbirds. Individuals who died of drowning, lightning or venereal disease were buried with liquid rubber poured on their faces. They went to a heaven where all was green and they prospered greatly. However, most of those who died went to *Mictlán*, the land of the dead and place of no outlets. Death in this case was considered a difficult journey.

As the Aztec body was put to rest, offerings were placed with it, and these offerings were to be used by the soul of the deceased in its travels as these chants indicate:

> Behold wherewith thou shalt pass there where the mountains come together. And behold how with this thou shall pass the road which the serpent watcheth. And behold wherewith thou shalt pass the green lizard, the *xochitonal*. And behold wherewith thou shalt cross the eight deserts. And behold wherewith thou shalt go over the eight hills. Behold wherewith thou shalt travel the place of the obsidian-bladed winds . . .

> It was said that they would encircle themselves (with offerings) and thus be protected in the place of the obsidian-bladed winds, and not suffer greatly. And he who had nothing among his wretched belongings, who went bare, underwent much pain . . .

> And also they caused him (the deceased) to carry a little dog, a yellow one; they fixed about its neck a loose cotton cord. It was said that [the dog] bore [the dead one] across the place of nine rivers in the land of the dead. (Sahagún, 1952: Appendix to Book 3, Chapter 1).

The Aztecs decorated the body of the deceased with paper streamers wrapped around it. Sometimes a stone mask was attached to the head and a green stone placed in the mouth. Except for the special cases mentioned above, the corpse was cremated, important people being accompanied not only by the offerings and the dog but also by sacrificed slaves (not cremated) to act as servants in the land of the dead.

In both West Mexico and on the Gulf Coast we see patterns somewhat similar to the Aztec. West Mexican Tarascan lords, for whom we have detailed historical descriptions, were cremated and a number of their servants were made drunk and then beaten to death in order to accompany them. The servants were buried separately from the ashes of the lord which were gathered up along with "melted gold and silver, a turquoise mask, his gold earrings, his feather braid, a large plumage of many rich green plumes on his head, his gold anklets, his turquoise collars, some sea shells, a round gold shield at the back and at the side, his bow and arrows, the tiger skins for the wrists, his leather war jacket and the gold leg bells." (Chronicles of Michoacán, 1970:47). All of these things were buried in a deep tomb in which a large number of blankets, pottery vessels containing food, mats and feathers had been placed.

In many cultures the dead are honored because they provide the necessary connection between the living and the remote forces of the supernatural. In Mexico, one important and probably very ancient aspect of religious observance and belief was concerned with the welfare of the dead, with the ancestral souls. For example, the Chronicles of Michoacán indicate that the Tarascans believed their ancestors to be united with the gods and for this reason held their customs sacred. This document cites a ritual that "is an old custom that comes down from their ancient old men whose ashes were saved because they were the first, according to these people, for man made gods from ashes . . ." (1970: 38).

Death feeds the gods and the gods look after the living. Thus a cycle is established in which human sacrifice is justifiable and in which all death is seen as important and necessary. As Robert Hertz pointed out, death is a transition, an initiation to the spirit world.

> Once the individual has surmounted death, he will not simply return to the life he has left; the separation has been too serious to be abolished so soon. He is reunited with those who, like himself and those before him, have left this world and gone to the ancestors. He enters this mythical society of souls which each society constructs in its own image. But the heavenly or subterranean city is not a mere replica of the earthly city. By recreating itself beyond death, society frees itself from external constraints and physical necessities which, here on earth, constantly hinder the flight of the collective desire. Precisely because the other world exists only in the mind, it is free of all limitations: it is—or can be—the realm of the ideal. (1960: 79).

For the ancient Mexicans, it is clear that in this "ideal" world one was better off with a collection of carefully made and select artifacts. Artifacts which were, for this reason, included in the burial and which now make up the major portions of collections of Precolumbian art.

The only dimension given is height in inches and centimeters. The date after the dimensions indicates the year the Lorans acquired the object.

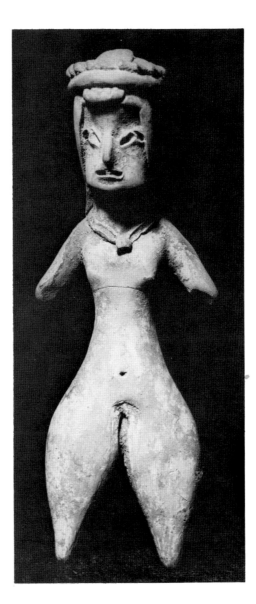

73
Solid Clay Figurine
Tlatilco Style (Type D-C9), Mexico, D.F.;
1000-500 BC
Clay; 4½" (11.43 cm.); 1964

By Middle Preclassic times, large villages of agriculturalists had established themselves in the Valley of Mexico. One of these villages, Tlatilco, was richer than the rest and its inhabitants were buried with elaborate pottery offerings including figurines. Since many of these tiny ceramic sculptures depict bare breasted females with heavy thighs, it has been thought that they were symbols of fertility. However, the existence of other types of depictions suggests a more complicated explanation, perhaps involving some kind of connection between the worlds of the living and the dead.

4
Plainware Bowls
Chupícuaro Style, Michoacán-Guanajuato;
500-100 BC
Clay; 2½" (6.35 cm.), 2¾" (6.98 cm.),
7½" (19.05 cm.), 4¼" (10.75 cm.),
2¼" (5.71 cm.); 1955

Pottery vessels and ceramic figures in the Chupícuaro style are found throughout Michoacán, in parts of Guanajuato and into the Valley of Mexico region. The site of Chupícuaro itself, a Late Preclassic village situated along the banks of the Lerma River, now lies beneath a lake recently created by the Solís Dam. From archaeological evidence, the people of Chupícuaro appear to have been intensely involved with the dead and focused a great deal of attention upon funerary preparations. Quantities of fine pottery vessels were made as offerings for the deceased. These wares, both plain and painted, are noted for their elegant and distinctive range of shapes.

75
Polychrome Bowls
Chupícuaro Style, Michoacán-Guanajuato;
500-100 BC
Clay: 6" (5.24 cm.), 6 5/8" (16.83 cm.); 1955

The extensive cemetary at the site of Chupícuaro gave evidence of complex mortuary ritual. Almost 400 human burials were excavated (there were also numerous dog burials), located around ash-filled basins or fire-pits apparently utilized in the funeral ceremonies. Cut human trophy-skulls, some painted with red pigment, were frequently included in the offerings to the deceased along with pottery vessels modelled into imaginative shapes and decorated in red, cream and black with characteristic geometric patterns.

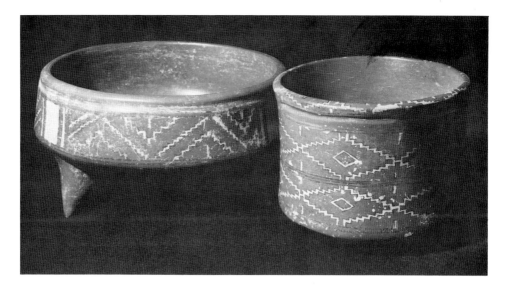

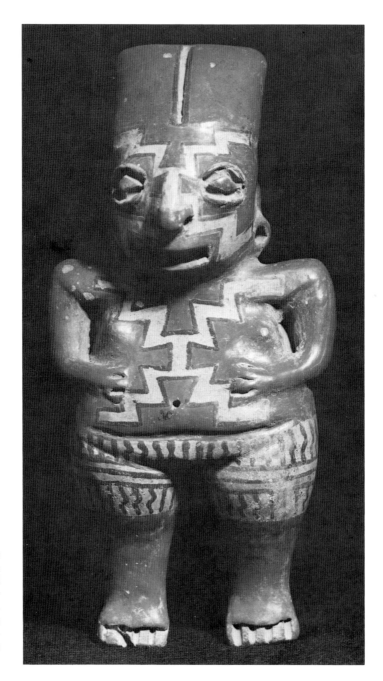

76
Standing Female Figure
Chupícuaro Style, Guanajuato-Michoacán;
500-100 BC
Clay; 10¼" (26.03 cm.); 1969

Chupícuaro style figures have been found as offerings in Late Preclassic burials located in the Valley of Mexico, apparently traded from their place of origin in Guanajuato or Michoacán. The Chupícuaro cultural complex now seems to have been part of the early West Mexican style development, perhaps forming a link between the Pacific coastal region and Central Mexico.

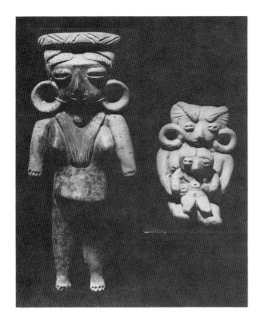

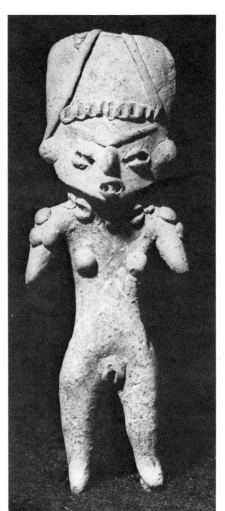

77

Female Figurines
Michoacán & Chupícuaro Style,
Michoacán-Guanajuato; 500-100 BC
Clay; 7¼" (18.41 cm.), 3½" (8.89 cm.),
4" (10.16 cm.); 1969, 1970, 1969

Figurines of the so-called "sexy lady" type are so common in Preclassic burial offerings from this part of West Mexico and they turn up unprovenanced in so many collections that it is often difficult to sort out styles as they change through time and over space. There was also a widespread trade in figurines in Preclassic times which further confuses the archaeological and art historical picture of their distribution. Of these three figurines, the two figures on the left are said to come from related sites in Michoacán and that on the right from the neighboring site of Chupícuaro. Besides the obvious emphasis on their female attributes, these figures all share an elaborate attention to headdress and decorative jewelry. Note the proportionally large ear spools on both of the Michoacán ladies and the tiny necklace on the infant.

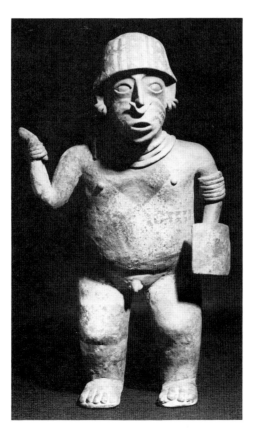

78

Standing Male Figure Holding a Shield and Blade
Nayarit-Jalisco; 200 BC - 200 AD
Clay; 21½" (54.61 cm.); 1949

Many of the works of art known from Precolumbian West Mexico were made as funerary offerings. These include large and small pottery figures as well as objects in stone, bone and shell such as musical instruments, jewelry, tools and weapons. These, and perhaps perishable items as well, were placed with the dead in shaft-chamber tombs. In Mesoamerica, this elaborate form of tomb occurs only in West Mexico, although similar types are also reported from northern South America. These tomb structures were carefully, often deeply, excavated and required considerable effort on the part of the living to insure a suitable resting place for the dead.

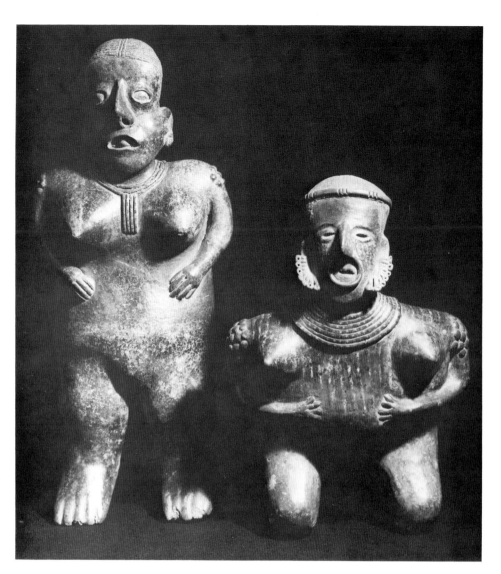

79
Female Figures
Nayarit-Jalisco; 200 BC - 200 AD
Clay; 16¾'' (42.54 cm.), 23'' (58.42 cm.);
1949, 1969

Most of the surviving ceramic sculptures from the region of West Mexico have come from tombs, some shallowly, others deeply excavated into the earth. These shaft-chamber tombs, as the characteristic form is called, consist of a vertical pit or shaft sometimes over fifty feet deep leading to lateral entrance passages connecting to burial chambers. Ceramic figure sculptures, other funerary offerings, and the bones of numerous individuals have been found in these chambers which may have served as family crypts. This type of large, hollow pottery figure, fired in a dark red and decorated with positive and negative (or resist) designs in cream and black, is included in a substyle known as San Sebastian Red. Tombs in the border regions of Nayarit and Jalisco are reported to contain San Sebastian Red type figures along with examples of several other distinct but related styles. Although there is the possibility that they are contemporaneous, the occurence of different styles within a single tomb may be due to changes over time and the tomb's reuse over a number of generations.

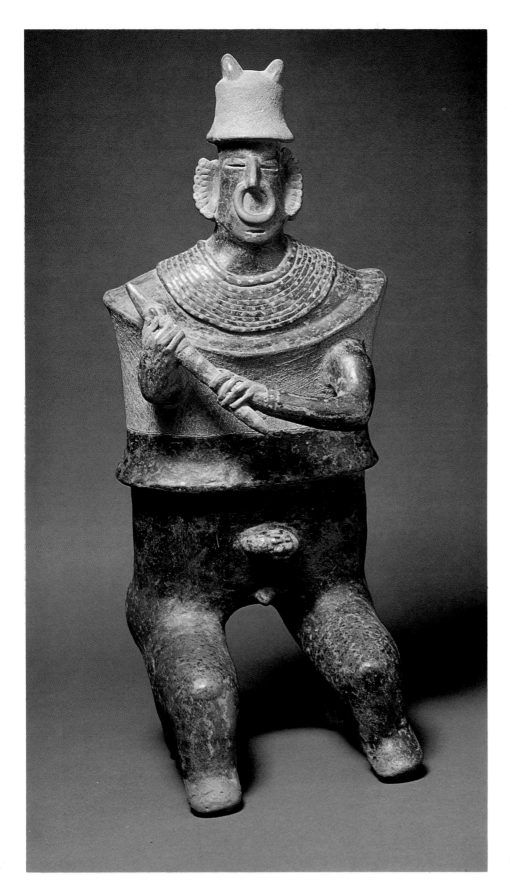

80
Seated Male Figure (Warrior?)
Nayarit-Jalisco; 200 BC - 200 AD
Clay; 26¼" (66.67 cm.); 1957

This large, hollow figure is shown carrying a mace and wearing a horned or protective cap and a thick, shirt-like garment, apparently representing a type of armor worn in ancient West Mexico. Although the figure seems clearly dressed for battle, the interpretation of these sculptures as warriors has recently been questioned. Instead, it has been suggested that they may depict shamans who battle with the supernatural. As yet, however, there is little archaeological evidence for any specific interpretation. This particular example, seated and wearing an elaborate necklace, may also have incorporated symbolic elements of the rank and status of the elite.

81

Female Figures Holding Bowls
Nayarit; 200 BC - 200 AD
Clay; 11″ (27.94 cm.), 7½″ (19.05 cm.);
1949

Although their features and proportions may be stylized and exaggerated, many Nayarit figures are depicted with elements of realistic detail such as costume, ornaments and body paint or tattoo and in poses which suggest action and narrative. Female figures holding bowls are frequently the subject of this mortuary art and may have been intended to act as "providers" of food and sustenance to the deceased in the after-life.

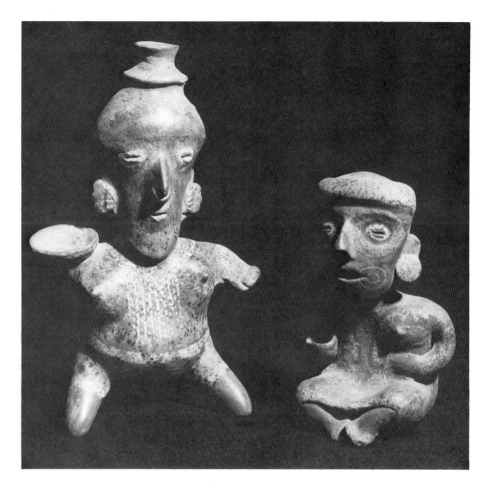

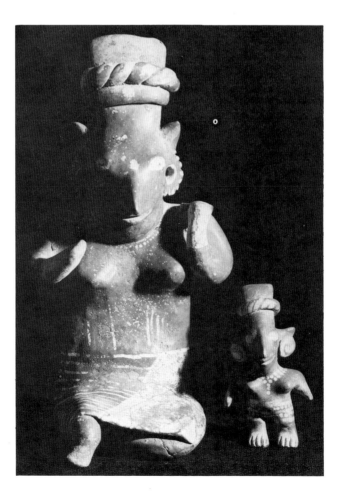

82

Female Figures
Nayarit; 200 BC - 200 AD
Clay; 12″ (30.48 cm.), 4¾″ (12.06 cm.);
1969, 1970

West Mexican tomb sculpture is characterized by figures portrayed in active poses and engaged in a wide variety of activities. These two lively and expressive female figures are typical of this art which seems more concerned with observation, narrative and caricature of daily life than with themes of a religious or supernatural nature. However, all archaeological evidence points to the funerary purpose for which this art was created and its constant association with the dead, apparently denying its secular character.

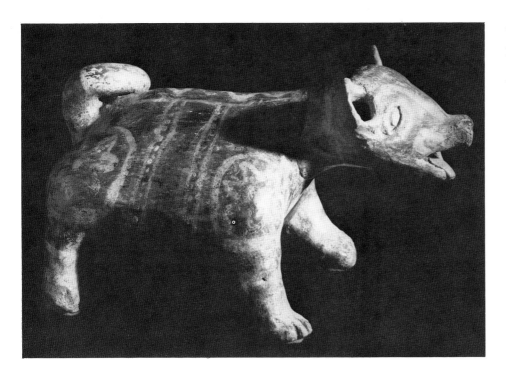

83
Animal Figure
Nayarit; 200 BC - 200 AD
Clay; 5 7/8" (14.83 cm.); 1971

West Mexican artists also depicted a wide range of local fauna in clay. Best known for their observant renderings of land and sea life are the potters of Colima, but there are fine, although rare, examples made by artists within other West Mexican style traditions as well. The Nayarit sculptor who made this amusing, four-legged creature painted fanciful designs in cream slip on the polished red surface, in keeping with what has been called the "classic" Nayarit substyle from Ixtlán del Río.

84
Seated Female Figure
Chinesco Style, Nayarit; 200 BC - 200 AD
Clay; 7¾" (19.68 cm.); 1969

Tomb sculpture from Nayarit shows wide stylistic diversity. Among the most elegant and delicate sculptures within this regional grouping are the so-called Chinesco (sometimes given feminine gender, Chinesca— "Chinese-like") figures. These range from fairly realistic to highly stylized representations, primarily of male and female human figures which are usually shown kneeling or seated with legs outstretched. The characteristic serenity of the Chinesco style, seen in this figure's pose and expression, is balanced by the lively surface decoration in red, cream and black on face and body.

85
Male and Female Figurines
Zacatecas Style, Zacatecas-Jalisco;
200 BC - 200 AD
Clay; 14 1/8″ (35.86 cm.), 15¾″ (40 cm.);
1971

Although given the name of the Mexican
state Zacatecas, documented examples of
this style of tomb sculpture have been found
in neighboring regions of northeastern Jalis-
co. In addition to their distinctive eye and
ear forms and unusual features of body and
surface decoration, male Zacatecas figures
usually wear a curious "horned" hairstyle
or headdress.

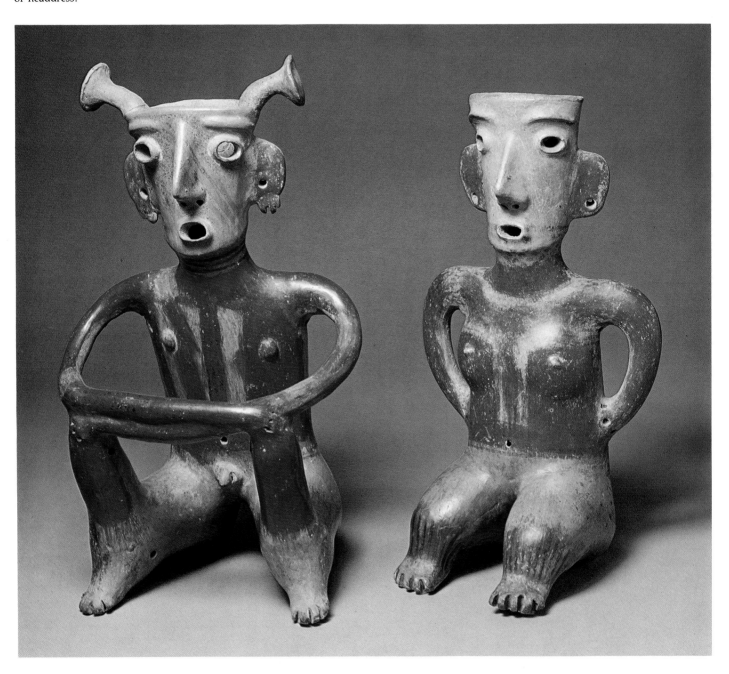

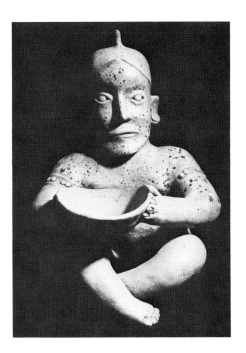

86
Seated Female Figure
Jalisco; 200 BC - 200 AD
Clay; 15¼" (38.73 cm.); 1969

This large sculpture portraying a seated woman holding a bowl can be included in one of the characteristic Jalisco substyles known as Ameca Grey, thought to originate in the Magdalena Lake district in the northeastern part of the state. Figures in this style are often slipped an elegant cream color, sparingly detailed with red and black, and the surface polished to a high sheen. The problem of the exact chronological position of these Ameca Grey figures in relation to other substyles of this northern Jalisco—southern Nayarit region is still under debate, but they are believed to be slightly later than the San Sebastian Red type sculptures (plate 79).

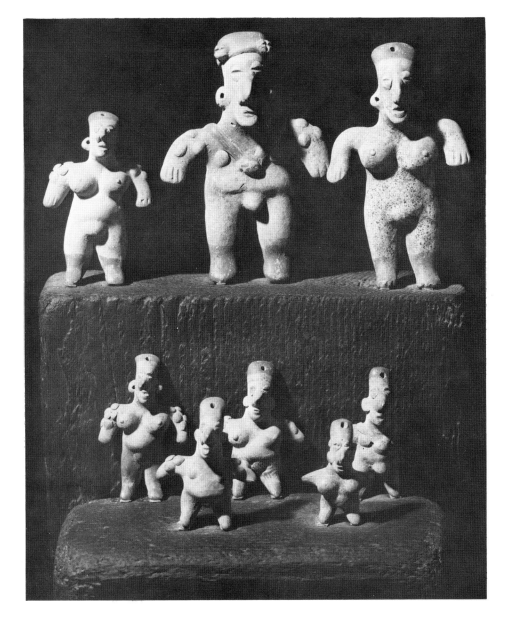

87
Group of 8 Figurines
Jalisco; 200 BC - 200 AD
Clay; 4½" (11.43 cm.) to 1¾"(4.44 cm.); 1967

With one exception, all of these tiny, solid Ameca Grey type figurines have perforations through the top of the headdress as though they were made to be strung together, perhaps as a necklace of charms or amulets. Even on the smallest examples, facial and body features are finely modelled, the cream slip with which they were painted is burnished, and details of costume or ornament are carefully delineated.

Figure with Elaborate Headdress
Colima; 200 BC - 200 AD
Clay; 14″ (35.56 cm.); 1971

While the mere existence of deep-shaft tombs
in Colima indicates social stratification of
some sort, the headdress and jewelry de-
picted on this figure illustrate a very special
status. The unique headdress, with face
mask looking skyward and crest of horns,
evokes a religious feeling while the body
position and facial expression suggest the
deep trance of a shaman whose soul has left
to travel in the spirit world. Recent studies
of modern Mexican shamans (Castañeda:
1968, 1971 and Furst: 1966, 1972) have given
rise to a reevaluation of many of the activi-
ties represented in the ancient figurine art of
West Mexico. Figurines which were for-
merly identified as mourners may alterna-
tively be initiates under the influence of a
hallucinogenic peyote plant which produces
long trances and visions. Figures in "warrior
poses" may be shamans doing battle with
supernatural forces. While we must use
caution in extending modern Indian prac-
tices and beliefs back into ancient times, we
are, as a result of this kind of study, forced
to realize the potential complexity of mean-
ing relayed by these ancient figurines, and to
back away from simplistic or ethnocentric
interpretations.

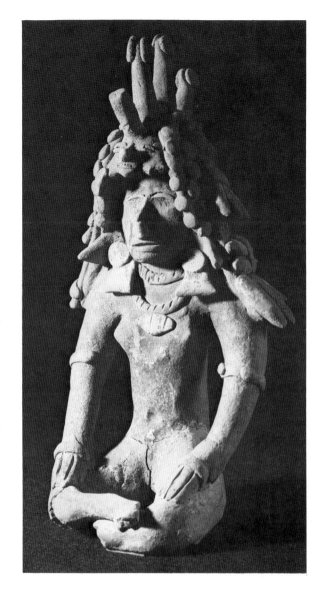

89

Dog Effigy Vessels
Colima; 200 BC - 200 AD
Clay; 4¾″ (12.06 cm.), 5″ (12.7 cm.),
10″ (25.4 cm.); 1970, 1971, 1959

Modelled pottery figures of dogs are of
major significance in the funerary art of
Colima. Red-slipped and highly polished,
they are often sculptured as containers or
effigy vessels with the aperture on the back,
tail or head. The iconographic and mortuary
importance of this motif may derive from
concepts of a mythical dog who was believed
to lead the souls of the deceased across the
River Apanoayán and past other dreaded
obstacles to the land of the dead. Another
explanation for the presence of numerous
pottery dog figures in burial offerings is that
they were believed to serve as sustenance for
the deceased. From historical sources it is
known that dogs were raised and fattened
for food in Precolumbian Mexico. Although
there are a number of representations of
what seem to be emaciated animals, the
majority of Colima pottery dogs appear
quite fat—as are these rotund examples.

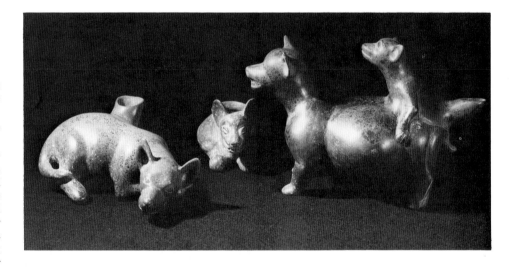

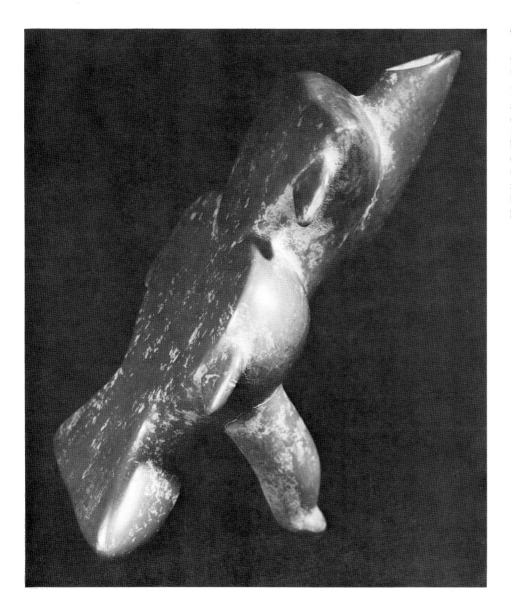

90
Aviform Backrest (*Reclinatorio*)
Colima; 200 BC - 200 AD
Clay; 11" (27.94 cm.); 1969

Pottery vessels shaped as backrests are among the unusual forms in the Colima ceramic style. Miniature versions of the *reclinatorio* are frequently modelled on the backs of little human figures who carry them or sit resting against them. These same figures also carry staffs, play musical instruments or hold elaborate fans, perhaps indicating that the backrest was reserved for privileged individuals.

91
Group of Figurines
Colima; 200 BC - 200 AD
Clay; 4¾" (12.06 cm.), 6¼" (15.87 cm.),
6¾" (17.14 cm.), 8" (20.32 cm.), 7¾"
(19.68 cm.), 6½" (16.51 cm.); 1949, 1955

Besides the large, hollow ceramic sculptures, there is also a wide variety of small, solidly modelled figurines in the Colima style. Both types may be found in the same tomb. The small figurines are often shown in animated poses and are reported to occur in burials as pairs or in groups forming scenes such as dancers, musicians, and their audience.

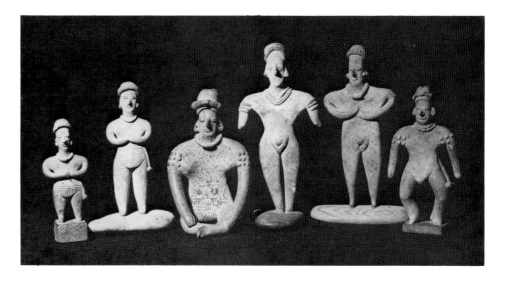

92
Effigy Vessel of Warrior or Shaman
Colima; 200 BC - 200 AD
Clay; 17" (43.18 cm.); 1965

Colima artists frequently represented male
figures dressed in thick, barrel-like body
armor and forcefully posed as if ready for a
battle. This figure holds a sling in his hands
and the vessel's aperture is modelled as his
protective helmet.

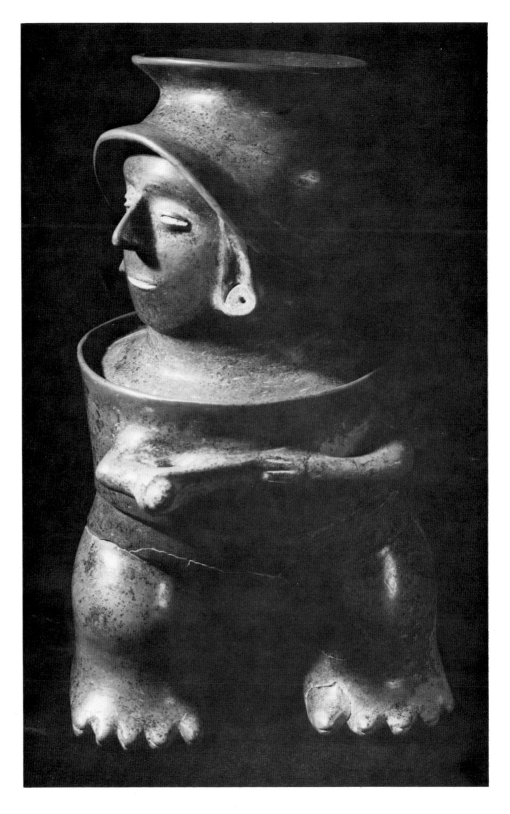

93
Stone Animal Sculpture
Colima; 200 BC - 200 AD
Stone; 7″ (17.78 cm.); 1955

Beyond the limits of the Mezcala lapidary tradition found in the Rio Mezcala and Rio Balsas basins in highland Guerrero, stone sculpture from West Mexico is exceedingly rare. This charming animal figure, probably representing a dog, is not unlike some of the ceramic zoomorphs from Colima. The shape of the eyes and ears indicate these details were "added on" rather than rendered in a subtractive technique appropriate for stone, and give the impression that the carver was accustomed to working with clay.

94
Stone Figures
Mezcala Style, Guerrero; 100-300 AD
Stone; 5 7/8″ (14.83 cm.), 3¼″ (8.25 cm.),
6½″ (16.15 cm.), 10″ (25.4 cm.); 1948

A complex picture is beginning to emerge as archaeologists learn more about the prehistory of Guerrero. In Preclassic times strong Olmec influences were felt in the Central Highlands and southern coastal regions of the state. In the Late Preclassic and Early Classic periods, the southern region came under the influence and perhaps domination of Monte Albán. Teotihuacán influence was present in the south, perhaps by way of Monte Albán, but it was much more pronounced in the Central Highlands, particularly in the Rio Balsas region where there may have been commercial exchange with the Valley of Mexico, especially in stone carving. Stark carvings which seem to emerge from the basic shape of an ax or celt are characteristic of the local Mezcala style of this highland area of Guerrero. They are sculptured from different kinds of hard stone in various colors ranging from light grey and deep green to black. Highly polished, schematically rendered human representations such as these examples predominate but there are also animal forms, masks, pectorals, beads and even small models of buildings resembling temples which are often carved with a small figure seated within.

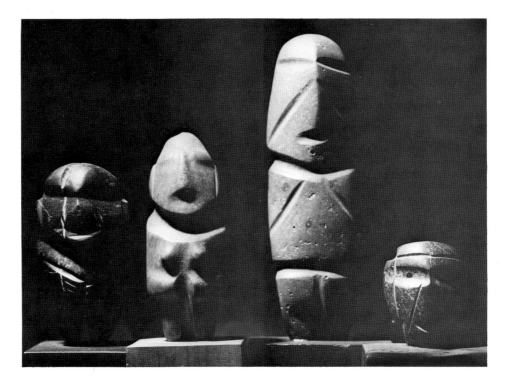

95
Standing Stone Figure
Teotihuacán-Guerrero Style, Guerrero;
100-300 AD
Stone; 10½" (26.67 cm.); 1955

This figure is carved with the flat planes and
the cut-out ovals separating arms from body
trunk that characterize the Mezcala style
sculpture from the upper Rio Balsas and
Mezcala area of the state of Guerrero. How-
ever, the face of the figure is done in the
Early Classic Teotihuacán style (plate 97)
and probably is an indication of the growing
influence of that central Mexican city on
outlying areas. It has been suggested that
this part of Guerrero was a stone source for
central Mexico, and even that some of the
stone carving attributed to the central region
was actually done by craftsmen from the
valleys of the Mezcala.

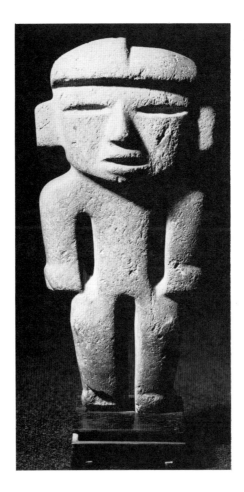

96
Tripod Bowl
Teotihuacán III Style, Central Mexico;
300-600 AD
Clay; 5¼" (13.33 cm.); 1969

This is the classic Teotihuacán shape often
found with disarticulated burials beneath
the floors of the apartment complexes of the
famous city of Teotihuacán. The most ele-
gant of the tripod bowls are decorated with
inlaid designs of lacquer paint in a technique
called "paint-cloisonné." These types of
vessels usually had slightly conical covers
with lug handles, and were always used for
ceremonial rather than utilitarian purposes.

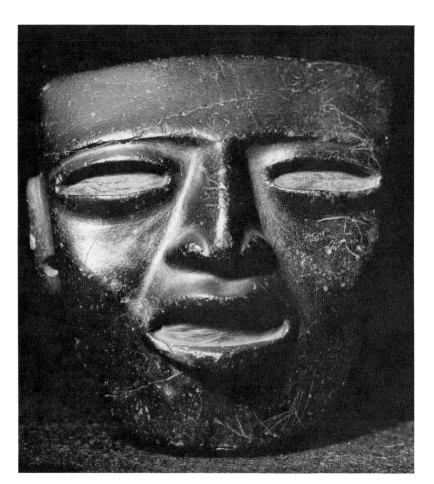

97
Green Stone Maskette
Teotihuacán Style, Central Mexico;
300-600 AD
Stone; 4" (10.16 cm.); 1949

Small stone masks, generally less than life-size, make up an important category of Teotihuacán art, but are actually somewhat rare at Teotihuacán itself. Stylistically related to the more common clay figurines, the stone masks are felt to have served as burial offerings which were placed over the face of the deceased at the time of entombment. The stone carver left the eye sockets and mouth unfinished, and these were probably meant to be filled with shell inlay. The straight cut forehead suggests that a headdress may have also been attached. Stone masks of this type are nearly always very stylized rather than portraits of individuals.

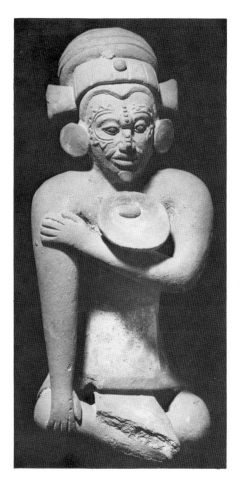

98
Seated Figure of a Man
Maya, Jaina Style, Campeche; 600-900 AD
Clay; 7" (17.78 cm.); 1964

The island of Jaina just off the coast of Campeche was one of the great Maya cemeteries. Here, individuals were buried with offerings which usually included a finely made figurine such as this example. It is not clear just what these delicate sculptures represented for the living or the dead, but they have become recognized as among the finest examples of the Mayan sculptural art. They were first mold-made and details were then modelled on the figure. Details of dress and jewelry are shown with great clarity and the figures seem to represent individuals.

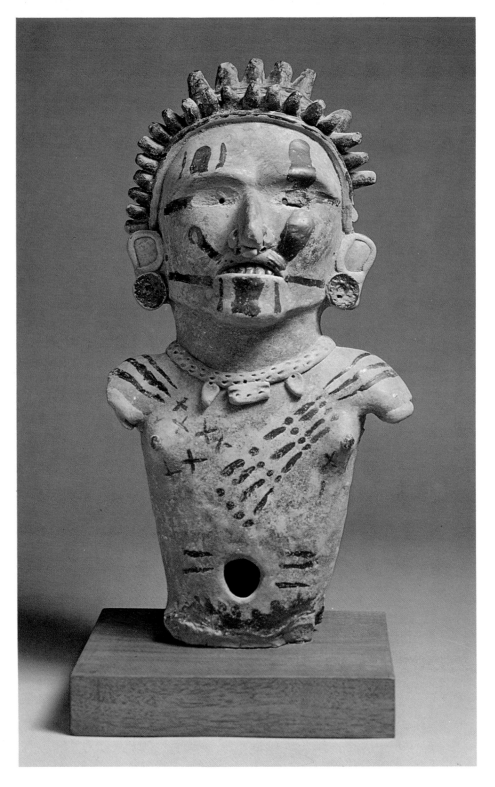

99
Torso of a Female
Lower Remojadas Style, Veracruz;
150 BC - 150 AD
Clay; 18″ (45.72 cm.); 1955

The black painting on this figure probably indicates magical or religious symbolism rather than simple body decoration. This black color is obtained from a mixture of plant resins, asphalt, and soot. It was commonly used to coat or mark out body features and ornament in the Veracruz ceramic tradition.

100
Seated Figure Holding Vertical Shaft of Fire Drill (?)
Remojadas Monumental Style, Veracruz;
200-500 AD
Clay; 17″ (44.45 cm.); 1971

This is a particularly good example of the Gulf Coast sculptor's ability to combine realistic body posture, dress, and ornamentation with the trance-like stare and open-mouthed expression of death or the other world.

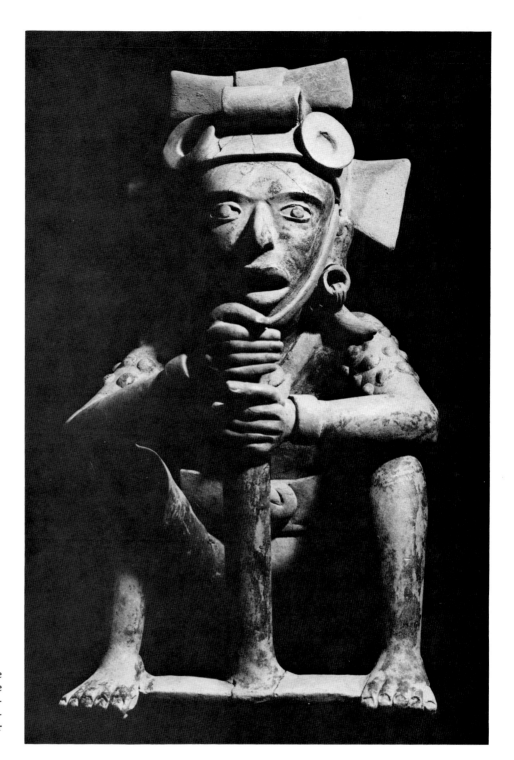

101
Head from "Smiling Figure"
Nopiloa II Style, Veracruz; 600-800 AD
Clay; 5¼" (13.33 cm.); 1955

Smiling figures are common in the archae-ological record of Veracruz. They are often found within contexts suggesting ritual decapitation with the hollow body smashed or buried separately from the head. This sort of ceremonial treatment and the unique facial expression has led to the suggestion that the figures symbolize human impersonators of the gods. These individuals were dressed in elaborate costumes, given a strong drink (probably containing the hallucinogenic seeds of the morning glory, *Rivea Corymbosa*) and made to dance and sing until sacrificed as a necessary ritual of the Mesoamerican calendar. The scroll decorating the forehead of this specimen probably represents the tail of a monkey.

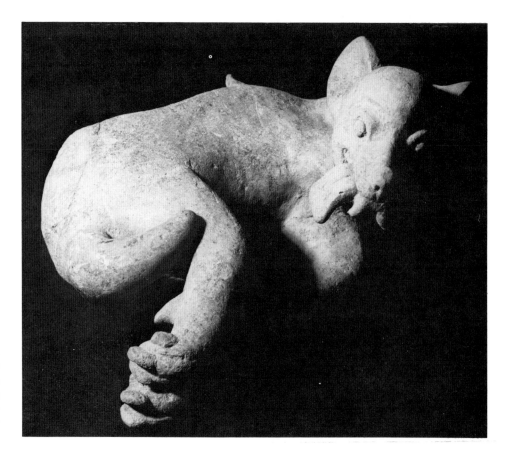

102
Reclining Figure of a Dog
Veracruz; 500-900 AD
Clay; 4" (10.16 cm.); 1971

This figurine cannot be identified as to precise stylistic tradition, although it is certainly from the Veracruz region. It portrays an emaciated dying dog with tongue hanging down. The large legs and claws give it a grotesque character which may again be suggestive of death or the underworld.

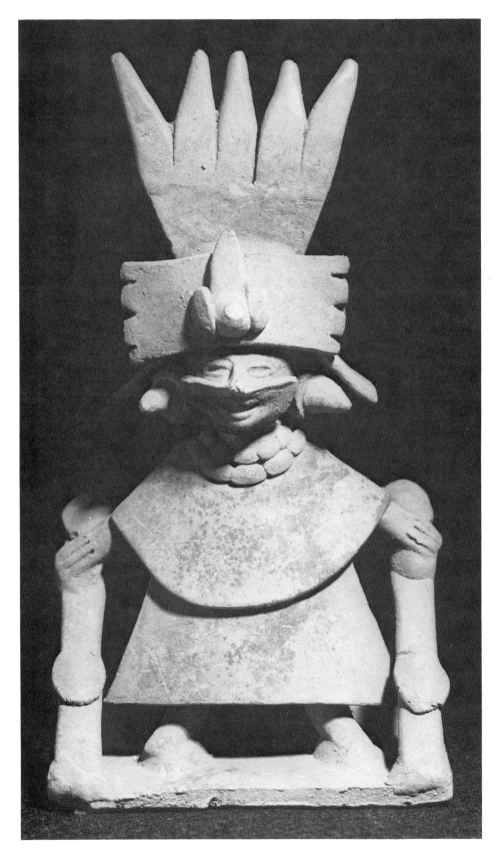

103
Smiling Figure on a Platform
Las Animas "Corrales" Style, Veracruz;
500-700 AD
Clay; 9½" (24.13 cm.); 1955

This type of smiling figure may represent a victim prepared for the arrow sacrifice or *tlacacaliliztli* known to have been practiced, with a similar kind of wooden framework, in Aztec times. The figure's elaborate headdress is interpreted to symbolize a diving bird.

104
Stone Figure of a Man
Huastec Style, Veracruz-Tamaulipas;
900-1200 AD
Stone; 38″ (96.52 cm.); 1947

These figures are generally interpreted as death images of important civic or religious officials. Although a large number are known, their cultural context has not yet been determined.

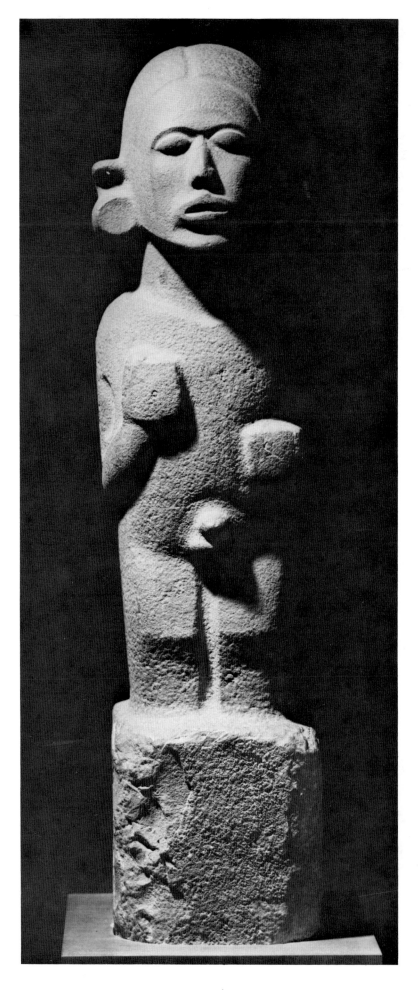

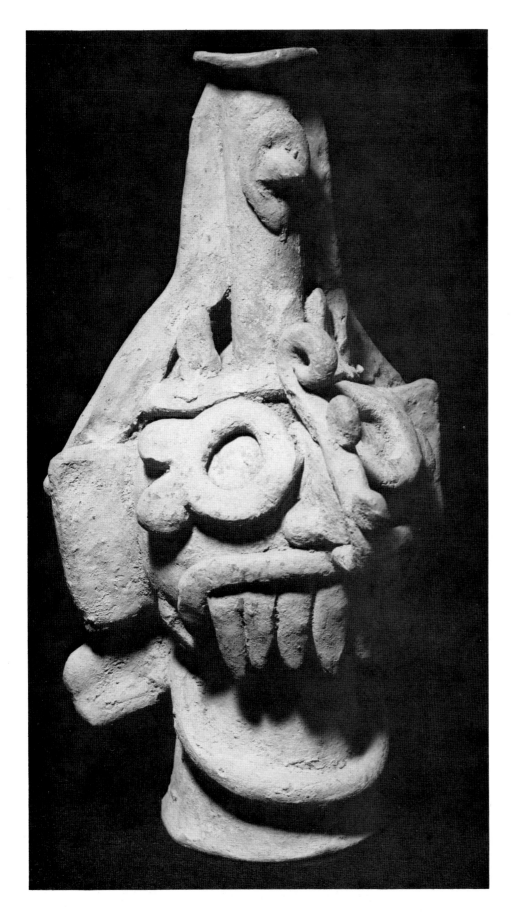

105
Clay Brazier (?)
Aztec-Toltec Style, Central Mexico;
1000-1500 AD
Clay; 13″ (33.02 cm.); 1955

This is a late representation of the Rain God, *Tlaloc*, defined both by the drooping projections from the top of the mouth (said to represent flowing water) and by the goggle eyes, another symbol of the rain-agriculture complex.

106
Stone Figure
Aztec Style, Central Mexico; 1200-1500 AD
Stone; 19½″ (49.53 cm.); 1969

This sculpture of volcanic stone represents a seated standard bearer. A pair of standing or seated figures flanked temple stair landings on Aztec pyramids. They usually had some provision such as a cupped hand for holding a pole with a flag on it which was put up during religious ceremonies.

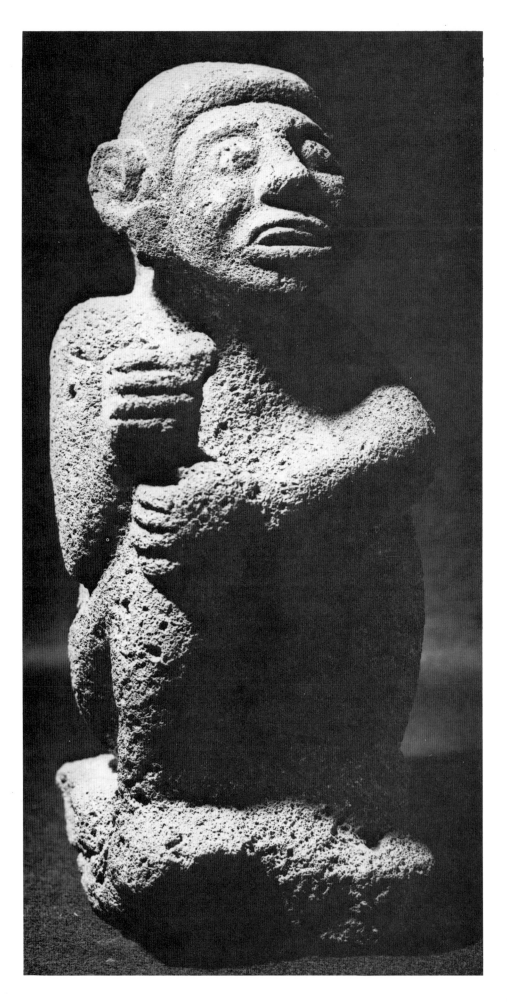

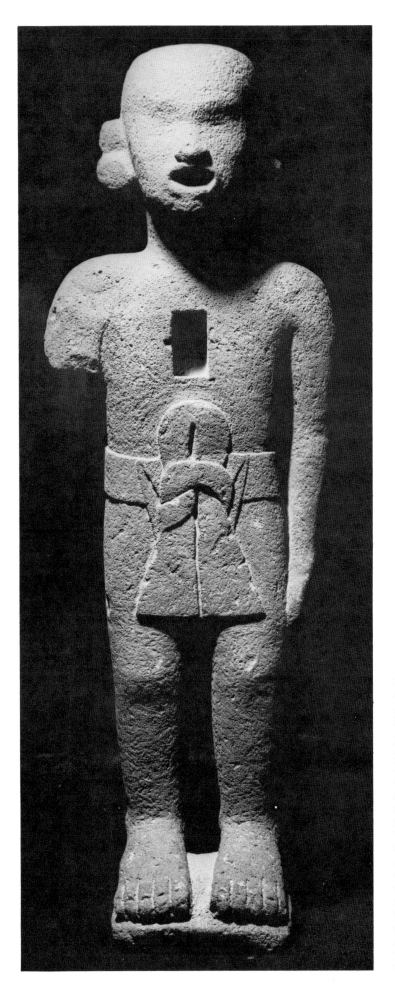

107
Stone Figure
Aztec Style, Central Mexico; 1200-1500 AD
Stone; 28¼″ (71.75 cm.); 1950

Most likely the image of a god, this figure
represents the combination of the deity in
human form and the sacrificial victim
turning into the divine. It has been sug-
gested that this type of nearly nude male
statue may have been dressed in perishable
clothing when used as a cult figure. In this
way a single statue could be used to repre-
sent several gods, for in Aztec religion each
god was distinguished by specific articles of
costume. Such a statue could also be dressed
and ornamented to signify specific attributes
of a single god as he presided over different
types of ceremonies. One can guess that the
square-cut opening in the chest of this figure
represents the missing heart of the human
victim and also serves as a repository for
that heart as it is given in offering.

Castañeda, Carlos. The Teachings of Don Juan: A Yaqui Way of Knowledge. Berkeley and Los Angeles, University of California Press, 1968.

Castañeda, Carlos. A Separate Reality: Further Conversations with Don Juan. New York, Simon and Schuster, 1971.

Chronicles of Michoacán. Trans. and ed. by Eugene R. Craine and Reginald C. Reindorp. Norman, University of Oklahoma Press, 1970.

Coe, Michael D. The Maya Scribe and His World. New York, Grolier Club, 1973.

Covarrubias, Miguel. Indian Art of Mexico and Central America. New York, Knopf, 1957.

Furst, Peter. Shaft Tombs, Shell Trumpets and Shamanism: A Culture-Historical Approach to Problems in West Mexican Archaeology. Ph.D. Dissertation, Los Angeles, University of California, 1966.

Furst, Peter. "To Find Our Life: Peyote Among the Huichol Indians of Mexico." In Peter Furst, ed., Flesh of the Gods: The Ritual Use of Hallucinogens. New York, Praeger, 1972.

Hammer, Olga, ed. Ancient Art of Veracruz. Los Angeles, Ethnic Arts Council, 1971.

Hertz, Robert. Death and the Right Hand. Glencoe, Ill., Free Press, 1960.

Kan, Michael, C.W. Meighan, and H. Nicholson. Sculpture of Ancient West Mexico: The Proctor Stafford Collection. Los Angeles County Museum of Art, 1970.

Leon-Portilla, Miguel. Ritos, Sacerdotes y Atavíos de los Oioses: Textos de los Informantes de Sahagún. Mexico, Universidad Nacional Autónoma de Mexico, 1958.

Meighan, Clement W. "Prehistory of West Mexico," Science, 184 (1974), pp. 1254-1261.

Sahagún, Fray Bernardino de. Florentine Codex: General History of the Things of New Spain. Trans. from the Aztec by Charles E. Dibble and Arthur J. O. Anderson. Santa Fe, School for American Research, 1950-1969.

Torquemada, Fray Juan de. Monarquia Indiana. Mexico, Editorial Porrua, 1969.

Wauchope, Robert, ed. Handbook of Middle American Indians. Austin, University of Texas Press, 1964.

Weaver, Muriel Porter. The Aztecs, Maya, and their Predecessors. New York, Seminar Press, 1972.

Willey, Gordon R. Introduction to American Archaeology. 2 vols. Englewood Cliffs, New Jersey, Prentice-Hall, 1966.

Africa Bibliography

Atkins, Guy. Manding Art and Civilization. London, Studio International, 1972.

Bascom, William. African Art in Cultural Perspective: An Introduction. New York, Norton, 1973.

Bascom, William. African Arts. Berkeley, University of California, 1967.

Bascom, William. The Art of Black Africa: Collection of Jay C. Leff. Pittsburgh, Carnegie Institute Museum of Art, 1970.

Bravmann, René. Islam and Tribal Art in West Africa. New York and London, Cambridge University Press, 1974.

Bravmann, René. Open Frontiers. Seattle and London, University of Washington Press, 1973.

Bravmann, René. West African Sculpture. Seattle and London, University of Washington Press, 1970.

Cole, Herbert. African Arts of Transformation. Santa Barbara, University of California, 1970.

Cornet, Joseph. Art of Africa: Treasures from the Congo. London, Phaidon, 1971.

d'Azevedo, Warren, ed. The Traditional Artist in African Societies. Bloomington and London, Indiana University Press, 1973.

Fagg, William. African Sculpture. Washington, D.C., International Exhibitions Foundation, 1969.

Fagg, William. African Tribal Images: The Katherine Reswick Collection. Cleveland Museum of Art, 1968.

Fagg, William. Miniature Wood Carvings of Africa. New York, Adams & Dart, 1970.

Fagg, William. Tribes and Forms in African Art. New York, Tudor, 1965.

Fraser, Douglas, and Herbert M. Cole, eds. African Art and Leadership. Madison, University of Wisconsin Press, 1972.

Goldwater, Robert. Bambara Sculpture from the Western Sudan. New York, Museum of Primitive Art, 1960.

Goldwater, Robert. Senufo Sculpture from West Africa. New York, Museum of Primitive Art, 1964.

Harley, George. Masks as Agents of Social Control in Northeast Liberia. Cambridge, Mass., Peabody Museum, 1950.

Harley, George. Notes on the Poro in Liberia. Cambridge, Mass., Peabody Museum, 1941.

Jahn, Janheinz. Muntu: The New African Culture. New York, Grove, 1961.

Kuchta, Ronald. Animals in African Art. Santa Barbara Museum of Art, 1973.

Laude, Jean. African Art of the Dogon. New York, Viking, 1973.

Leiris, Michel, and Jacqueline Delange. African Art. London, Thames and Hudson, 1968.

Leuzinger, Elsy. Africa: The Art of the Negro Peoples. New York, Crown, 1960.

Leuzinger, Elsy. African Sculpture. Zurich, Museum Rietberg, 1963.

Leuzinger, Elsy. The Art of Black Africa. Greenwich, Conn., New York Graphic Society, 1972.

Mbiti, John. African Religions and Philosophy. London, Heinemann, 1969.

Menzel, Brigitte. Goldgewichte aus Ghana. Berlin, Museum für Volkerkunde, 1968.

Moore, Gerald, and H. U. Beier, eds. Modern Poetry from Africa. Baltimore, Penguin Books, 1963.

Museum of African Art. The de Havenon Collection. Washington, D.C., 1971.

Ogunmola, Kola. The Palmwine Drinkard. University of Ibadan, 1968.

Parinder, Geoffrey. African Mythology. London, Paul Hamlyn, 1967.

Robbins, Warren. African Art in American Collections. New York, Praeger, 1966.

Rubin, Arnold. The Arts of Jukun-speaking Peoples of Northern Nigeria. Ph.D. Dissertation, Indiana University, 1969.

Sieber, Roy. African Textiles and Decorative Arts. New York, Museum of Modern Art, 1972.

Sieber, Roy. Interaction: The Art Styles of the Benue River Valley and East Nigeria. Lafayette, Purdue University, 1974.

Sieber, Roy. Sculpture of Northern Nigeria. New York, Museum of Primitive Art, 1961.

Sieber, Roy, and Arnold Rubin. Sculpture of Black Africa: The Paul Tishman Collection. Los Angeles County Museum of Art, 1968.

Sousberghe, L. de. L'art Pende. Brussels, Academy Royal de Belgique, 1958.

Soyinka, Wole. Dance of the Forests. New York, Oxford University Press, 1963.

Thompson, Robert. African Art in Motion. Berkeley and Los Angeles, University of California Press, 1974.

Thompson, Robert. Black Gods and Kings. Los Angeles, University of California, 1971.

University of California. African Studies Center. African Arts, volumes 1-7, 1967-1974.

Bibliography of Writings by Erle Loran

ESSAYS ON ART

"Cézanne's Country," The Arts, April 1930, p. 521.

"An Artist Goes to Italy," Part I, The Arts, May 1931,
p. 540; Part II, June 1931, p. 613.

"Cézanne at the Pennsylvania Museum," American Magazine
of Art, February 1935, p. 85.

"Artists from Minnesota," American Magazine of Art,
January 1936, p. 25.

"San Francisco's First Cézanne Show," Magazine of Art,
October 1937, p. 634.

Art reviews in The Argonaut, March 10, March 17,
March 24, March 31, 1939.

"Cézanne Still Life Analyzed," American Artist, March 1944,
p. 20.

"Art News from San Francisco," Art News, September 1949-
August 1954.

"Watercolor Series: Analysis by the Artist of a Recent
Painting, Coast Relics," American Artist, March 1950,
p. 52.

"Cézanne in 1952," Art Institute of Chicago Quarterly,
1 February 1952, p.1.

"Trial by Juries," Art News, December 1952, p. 25.

"Cézanne's Color," American Artist, September 1953, p. 54.

"Pop Artists or Copy Cats?" Art News, September 1963,
p. 48.

"Cézanne and Lichtenstein: Problems of Transformation,"
Artforum, September 1963, p. 34.

BOOK

Cézanne's Composition. Berkeley, University of California
Press, 1st edition, 1943; 2nd edition, 1944; 3rd edition,
1963.